# MATTIE LOU O'KELLEY

Folk Artist

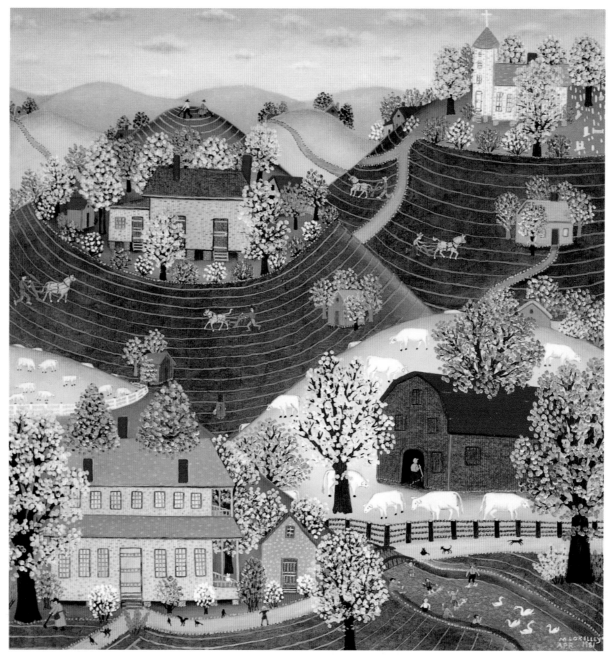

APRIL PLOWING

# MATTIE LOU O'KELLEY

❧

# Folk Artist

By Mattie Herself

Introduction by Robert Bishop

A BULFINCH PRESS BOOK • LITTLE, BROWN AND COMPANY

BOSTON • TORONTO • LONDON

FIRST EDITION

Library of Congress Cataloging-in-Publication Data

O'Kelley, Mattie Lou.
Mattie Lou O'Kelley, folk artist / introduction by Robert Bishop.
p.  cm.
"A Bulfinch Press book."
ISBN 0-8212-1744-5
1. O'Kelley, Mattie Lou.  2. Georgia in art.  3. Primitivism in
art — Georgia.  I. Bishop, Robert Charles.  II. Title.
ND237.O515A4   1989
759.13 — dc20   89-7973
CIP

A number of the paintings and accompanying text reproduced in *Mattie Lou O'Kelley: Folk Artist* were originally
published in *A Winter Place* (1982), *From the Hills of Georgia: An Autobiography in Paintings* (1983), *Circus*
(1986), and *The Mattie Lou O'Kelley Folk Art Calendar for 1987* (1986), all by Mattie Lou O'Kelley (Joy Street
Books published by Little, Brown and Company [Inc.]).

The following two paintings appear courtesy of the High Museum of Art:

page 7:  *Spring-Vegetable Scene*, 1968. Oil on canvas. Purchase. Permanent Collection of the High Museum of Art,
Atlanta, Georgia. 1975.37.

page 16:  *My Parents' Farm*, 1980. Oil on canvas. Gift of the artist in memory of her parents, Mary Bell Cox
O'Kelley and Augustus Franklin O'Kelley, and their children, Willie, Lillie, Gertrude, Ruth, Tom, Ben, Mattie Lou,
and Johnnie. Permanent Collection of the High Museum of Art, Atlanta, Georgia. 1980.68.

Photograph on page 75 by Jay: Leviton · Atlanta

Bulfinch Press is an imprint and trademark of Little, Brown and Company (Inc.)
Published simultaneously in Canada by Little, Brown & Company (Canada) Limited

PRINTED IN JAPAN

This book is dedicated to all those kind, patient people who kept faith in my artistic struggles till I rose up and out of an obscure existence to make a name for myself doing something that is a pure pleasure.

M. L. O'Kelley

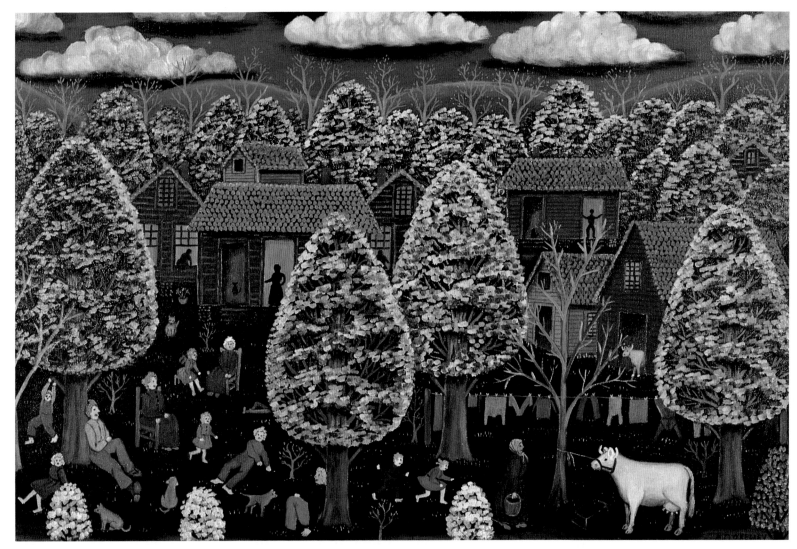

WAITING FOR BEDTIME

# INTRODUCTION

❦

In 1975, while I was on a trip to Atlanta, Georgia, to lecture about quilts and coverlets at the High Museum of Art, Gudmund Vigtel, the director, mentioned to me that a few days previously he had enjoyed a visit with a "painting lady" from nearby Maysville, Georgia. She had journeyed by bus to show him her pictures, which documented her life in the rural Georgia town. After my presentation, we stopped by his office and he showed me the canvas he had acquired for the museum. It was a rich, bountiful still life with a basket of lettuce and vegetables and fruit on a vibrant aqua-and-white-checkered tablecloth (*Spring-Vegetable Scene*, page 7). He explained that he had introduced the self-taught artist to the gift-shop manager and that several pictures were available in the museum store. When I saw the remarkable, finely detailed canvases and highly individualized "dot pictures," astonishment must have flushed my face, for here was a true American primitive — self-taught, an exquisite recorder of time and place, and, most compelling of all, an artist capable of rich detail and a variety of design and texture indicating a unique vision.

I immediately canceled my return flight to Detroit, where I was employed as director of publications at the Henry Ford Museum and Greenfield Village. I rented a car and drove off in quest of the artist whom I felt sure was the eighth wonder of the world. Actually, Mattie Lou O'Kelley was easy to find. Maysville was a small, sleepy town with a population of about eight hundred some fifty miles northeast of Atlanta. The clerk at the local grocery store — the only operating business on the main street — was helpful. Miss O'Kelley could be found in a cabin just behind the store and adjacent to the small factory where she worked.

Mattie Lou's house turned out to be a modest, one-room, weatherboard structure with a cement floor and a central door. The only window in the front of the dwelling was immediately to the right of the door. When I knocked, several minutes passed without a response. I was insistent, for I could hear someone inside, and I resolved to remain until I had actually met the artist. My heart pounded with excitement as my knuckles, now red from determination and repeated raps, finally drew out the handsome, blue-eyed woman who was to become my friend.

Mattie Lou was tall and slim, and, in those days, a very shy person. We talked extensively and agreed she would send photographs of new paintings to me as they were finished. I returned to Michigan and only as an afterthought realized that I had not been asked inside the cabin.

Over the next several months, Mattie Lou and I corresponded frequently. When the invitation for the "Missing Pieces" exhibit ("Missing Pieces: Georgia Folk Art 1770–1976," organized by Anna Wadsworth for presentation at the Atlanta Historical Museum) arrived, I decided to travel to the opening and to attempt to visit Mattie Lou at the same time. On this trip Mattie Lou, though still reserved, seemed more at ease. We drove about Maysville and nearby villages, visiting a woman friend and two of Mattie Lou's brothers, Tom and Ben. Upon returning to her cabin, I was asked if I would like to come in.

Mattie Lou had been reared in Maysville in a large family. She was born in 1908, the seventh of eight children. As her siblings left to establish their own families, she stayed home to care for an increasingly frail mother. Mattie Lou attempted to earn a living in many ways. In her autobiographical poem (page 77), she has recorded some of the trials that faced an unskilled woman in the rural South in the earlier half of the twentieth century.

In the next several years I introduced friends and collectors to Mattie Lou's paintings and occasionally acquired a piece for myself as well. It was during this period that her style crystallized. Her palette became fixed, and one could count on nearly every painting being a powerful work of art. I spent

many a morning waiting for the mail to see what new treasure she had created. I also began to write on a regular basis for several national magazines and frequently included her pictures in my articles on American folk, fine, and decorative arts.

How proud we both were when it was announced that Mattie Lou O'Kelley had been selected as a recipient of the Governor's Award in the Arts for the state of Georgia in 1976. Elaborate plans were laid. I would fly to Atlanta, drive northeast to pick up Mattie Lou, and together we would arrive for the award celebration at the High Museum. Mattie ordered a new dress from a mail-order catalogue. The reception was a great personal triumph for the emerging artist. I think for the first time in her life her overpowering shyness was replaced by a quiet confidence that comes only with personal experience and enthusiastic acceptance.

Mattie Lou was becoming famous. National magazines, newspapers, and television news editors all began to arrive at her doorstep. At first Mattie Lou felt honored by the attention. In time the din of activity became so great that she began to feel used. Her natural, solitary nature began to reassert itself, and she began to withdraw into her own world. All the time she continued to paint beautiful pictures. Oftentimes they were of local subjects, such as the mill (*The Old Mill*, page 35) that stood immediately next to her cabin.

Through the years several trips caused significant changes in her subject matter and style. On one trip we toured the Detroit area, and she expressed great interest in the heavily industrialized Lake Saint Clair waterfront and the tributaries of the rivers that flowed from it. Several colorful paintings document this excursion to the merchant-marine activities of the Midwest.

In 1977 I moved to New York to assume the directorship of the Museum of American Folk Art. I suggested Mattie Lou might enjoy trying the city as a place to live and paint. She ultimately decided to move to New York City. She was intrigued with the idea of being able to leave her apartment and have every public service available within a few steps. The apartment finally settled upon was a large studio by New York standards. She filled it with her treasured possessions from Maysville: boxes of her mother's canning, her mother's foot-treadle sewing machine, some of her cherished quilts, and numerous mementos, such as a glass jar covered with cement embedded with shells, rocks, and other found objects. All in all, the apartment was light and attractive, though her stay in the city was short-lived. The urban landscape, with its jostle of people from Madison Square Garden, near which she lived, and the cold winter, finally became a place from which to escape. Her conversations those days were full of warm climates and a little house in the sun.

By the late 1970s Mattie Lou enjoyed personal, artistic, and financial success. For several years, she was well represented by Jay Johnson, a young New York art dealer. The New York experience proved to be a remarkable catalyst for the artist. She recorded several of the small brick buildings in numerous paintings, such as *Rooms* (page 65). Visits to tourist sites, such as the Statue of Liberty, the Empire State Building, and a New Year's ball drop at Times Square, all provided an expanded visual experience that was reflected in her work. Still, her best paintings continued to be memory-inspired and to document the small-town life of agrarian Georgia in the early 1900s.

In an effort to find an ideal place to live, Mattie Lou traveled south. A visit to a friend in West Palm Beach prompted an excited call. I flew to Florida to inspect a small house located just a few blocks from her friend's and the Palm Beach airport, and a stone's throw from the beach. Eventually Mattie Lou moved into the newly renovated and refurbished dwelling. An uninterrupted flow of pictures continued to reach back to childhood experiences. Occasionally paintings drawn from local encounters appeared as well. The portrait of *Sassy Cat* (page 17), a neighborhood visitor to Mattie Lou's, was executed. Some of Mattie Lou's most beautiful floral paintings were created at this time.

The call of the familiar continued to strengthen, and ultimately the wandering artist decided to return to Georgia. Mattie Lou found a handsome apartment in the center of the town of Decatur. The location was practical — she could either walk or catch a cab to town, and there was a small shopping center nearby.

With the ever-increasing sales of her work, she began to consult with an attorney about card, poster, and reproduction rights. In the early 1980s, she produced the art for a wonderful book, *A Winter Place*, published by Atlantic Monthly Press/Little, Brown and Company. *From the Hills of Georgia: An Autobiography in Paintings* was released in 1983 and was a substantial success as well. Another book, *Circus*, followed in 1986. Calendars for national distribution and numerous commissions from major collectors and museums began to add significantly to this painting lady's reputation. Finally, television interviews, book signings, and even an illustration for the cover of *Life* magazine ensued. With public success, of course, comes the burden of being a public figure. This aspect of her life was not to her liking, and once again she became reclusive. It was in this period of solitude and introspection that Mattie Lou O'Kelley painted some of her most beautiful pictures, the masterpieces of her entire career.

Mattie Lou also was able to realize a longtime dream — to own her own house. She bought a brand-new two-story brick townhouse on the outskirts of Decatur. It is here that for the last several

years Mattie Lou has arduously pursued a very large, multi-painting commission for a major southern corporation. The idea is that the pictures will be kept together and one day either given to a museum or a museum will be built to house them. What a fitting tribute to one of America's greatest self-taught artists. Mattie Lou O'Kelley's visual history of rural life in the early twentieth century is unique. She has preserved for future generations moments in American history that will never occur again, and she has created a lasting artistic legacy for America.

I am proud to have known her and to be counted as her friend.

Robert Bishop
*April 1989*

# MATTIE LOU O'KELLEY

## Folk Artist

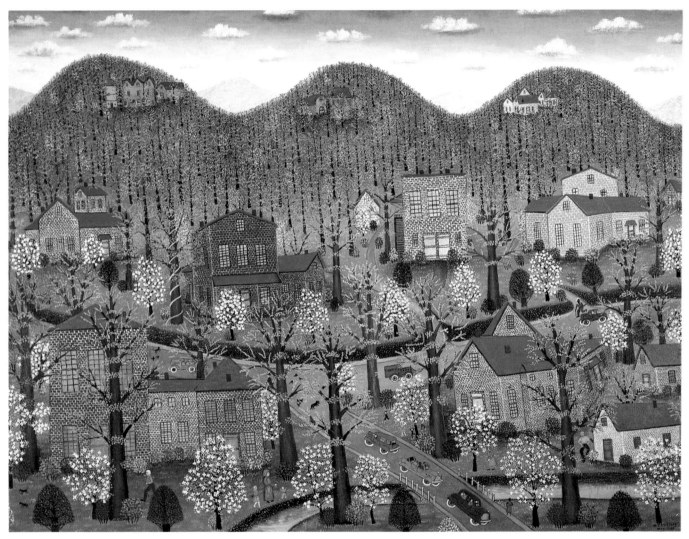

WHEN THE DOGWOODS BLOOM

# SPRING

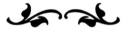

A warm day in the sun.

Corn to plant, cotton to plant. Shoes to mend.

Chickens sunning after a dreary winter.

Get along, poky mule.

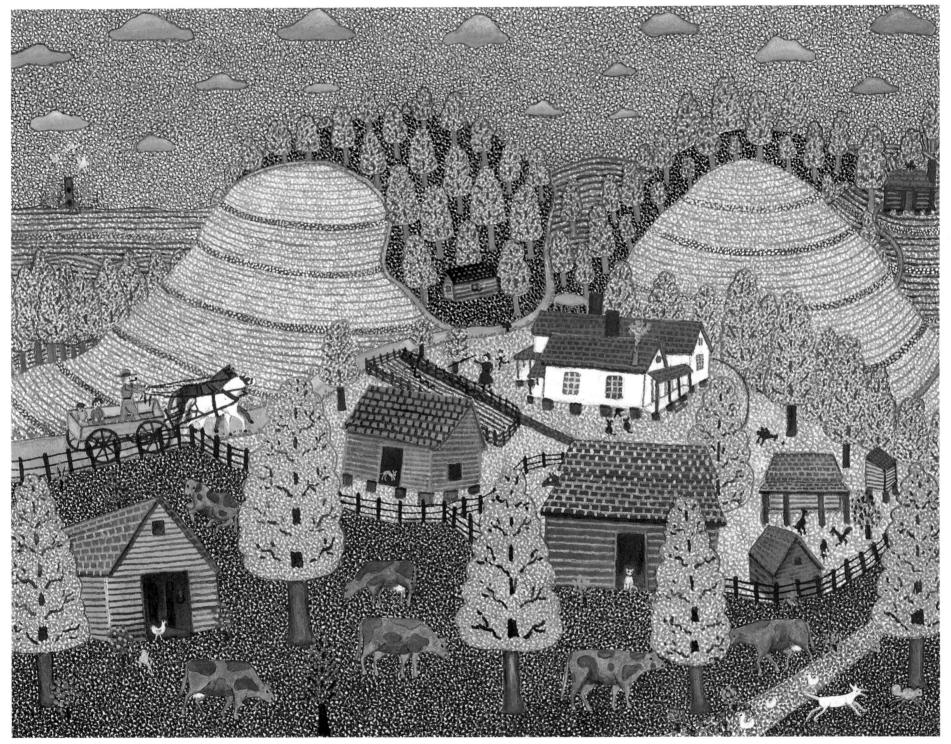

SPRING

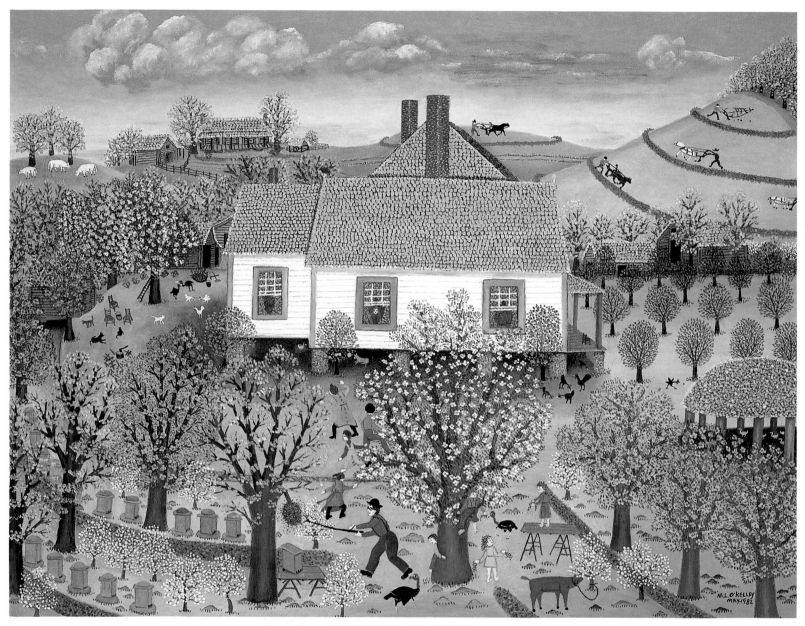

SPRINGTIME IN GEORGIA

$O$utdoors and barefoot after the long cooped-up winter. The peach trees and apple trees are blooming, but my favorite is the wild plum — soft as baby lace. We make playhouses and leaf hats down beneath the poplars until the bees come out.

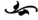

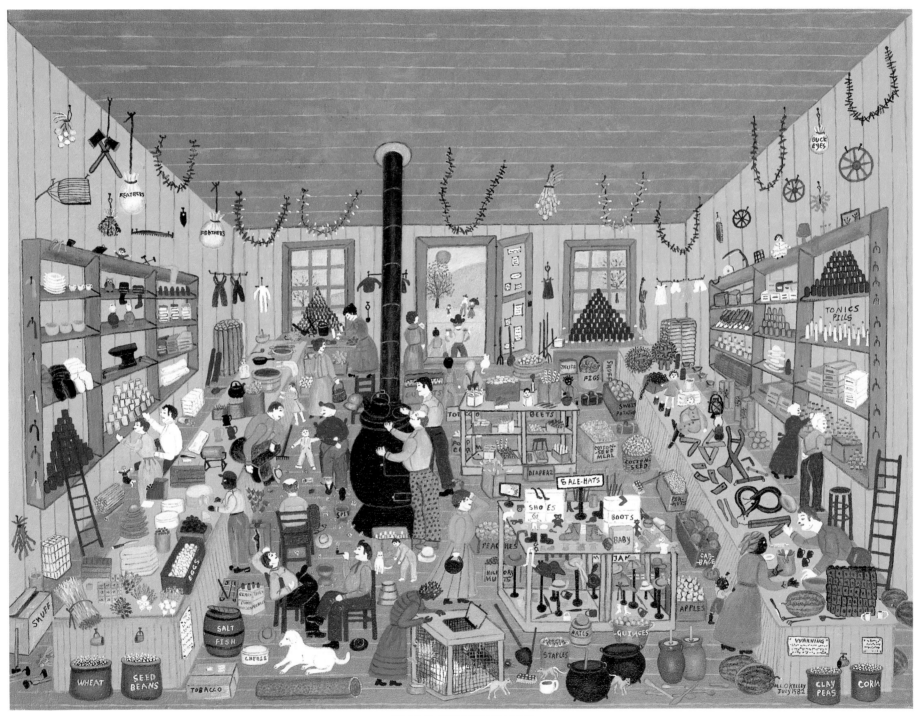

THE COUNTRY STORE

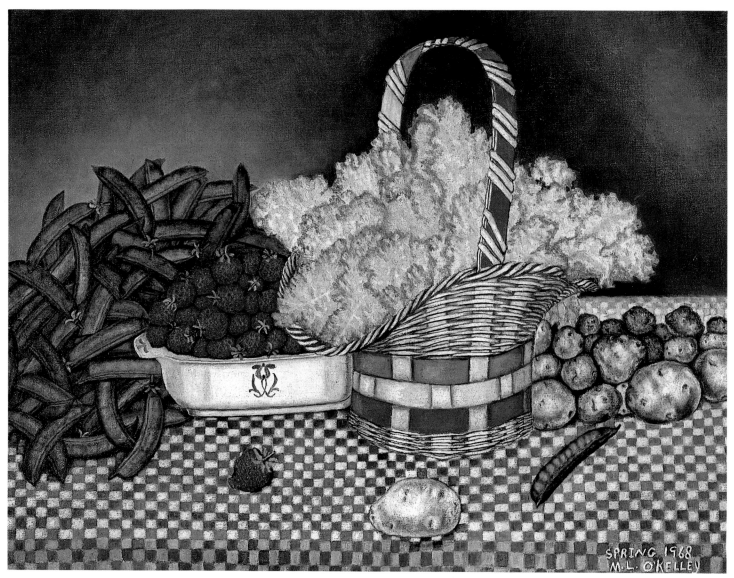

SPRING-VEGETABLE SCENE

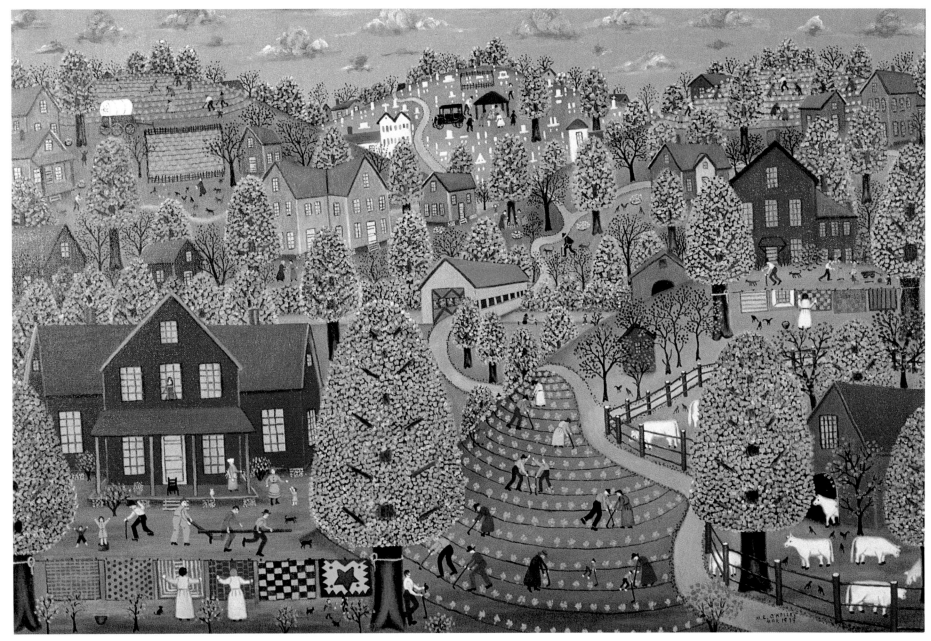

AIRING THE QUILTS

My mother was a true farmer's wife — working in the fields with her children,
sewing for them through the winter, using the scraps for quilts when idle from other chores.

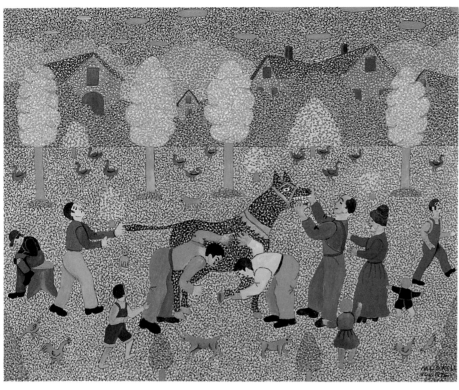

CHECKING OUT THE NEW MULE

P*apa liked to trade mules from time to time. I remember how the new mule when brought home got a bit of inspection.*

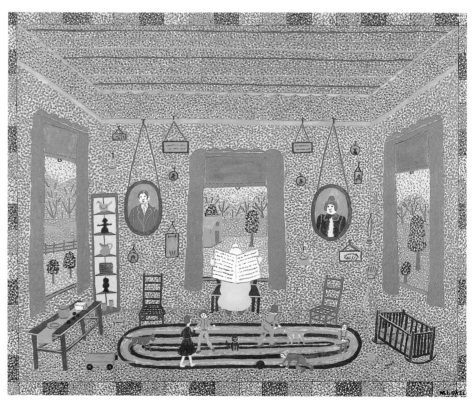

READING THE NEWSPAPER

9

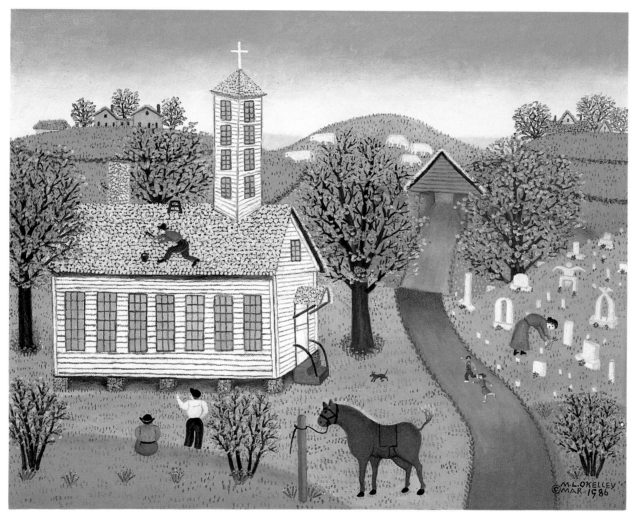

A SMALL CHURCH

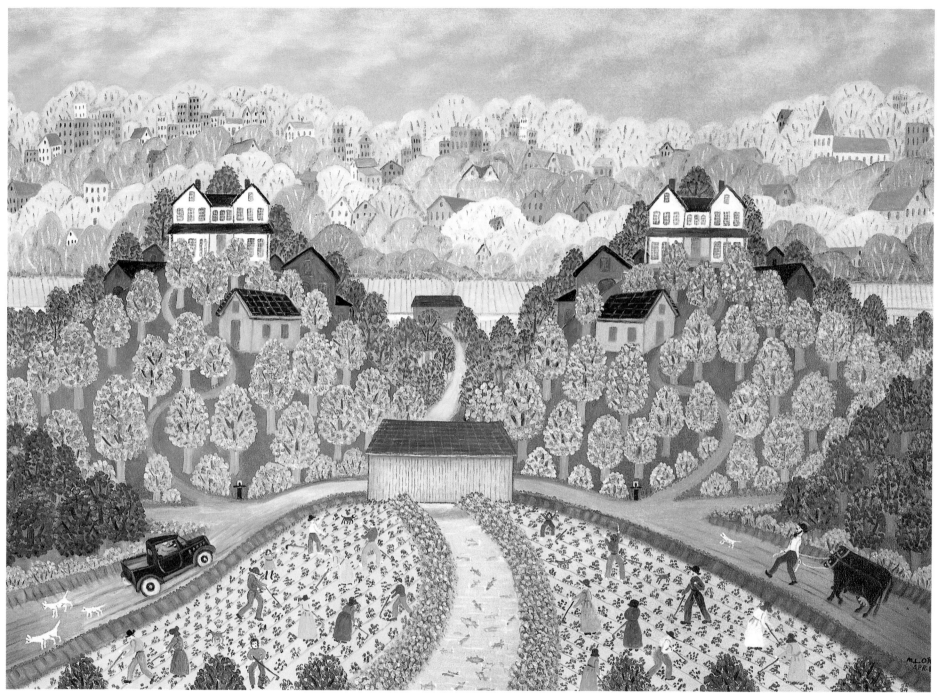

THE TWINS' PLACE

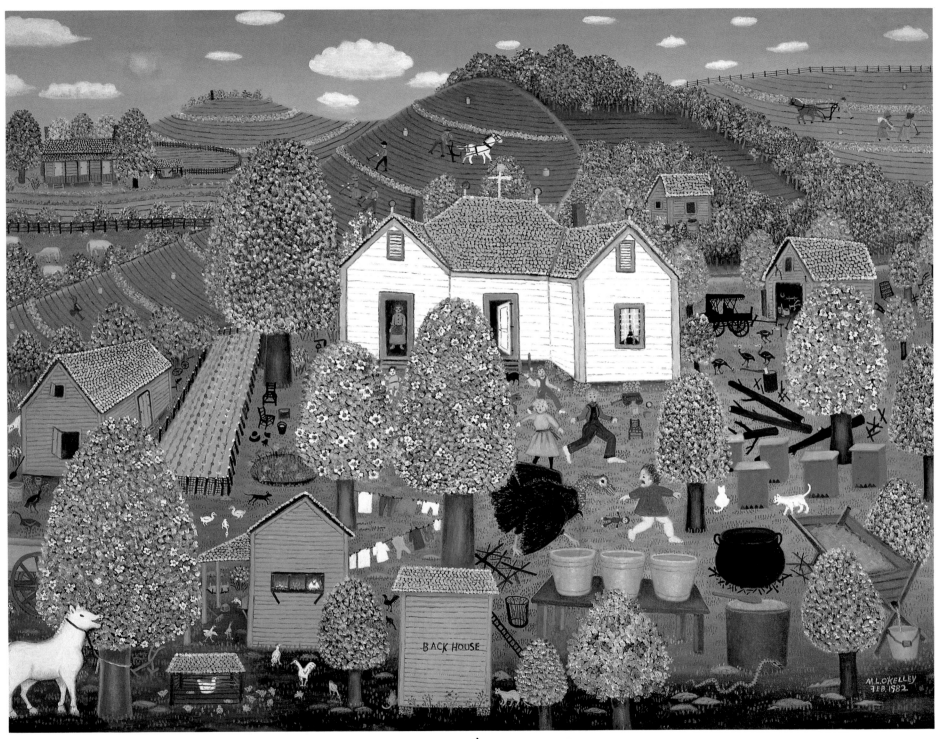

**SISTER GERTRUDE'S OLD GOBBLER**

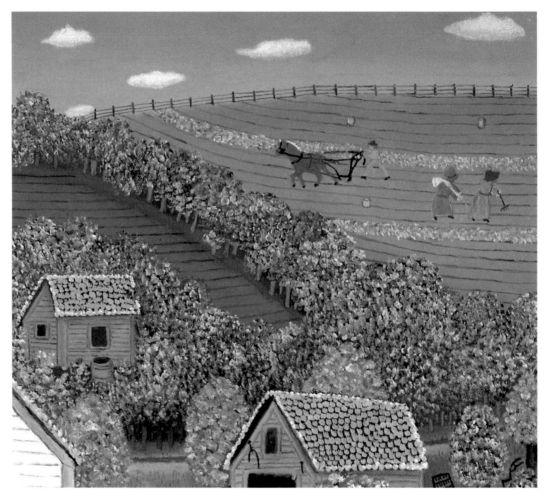

DETAIL

*That sassy gobbler seemed to know the minute I started down the long back doorsteps. Out he came from under the house, spreading out his feathers like a thundercloud.*

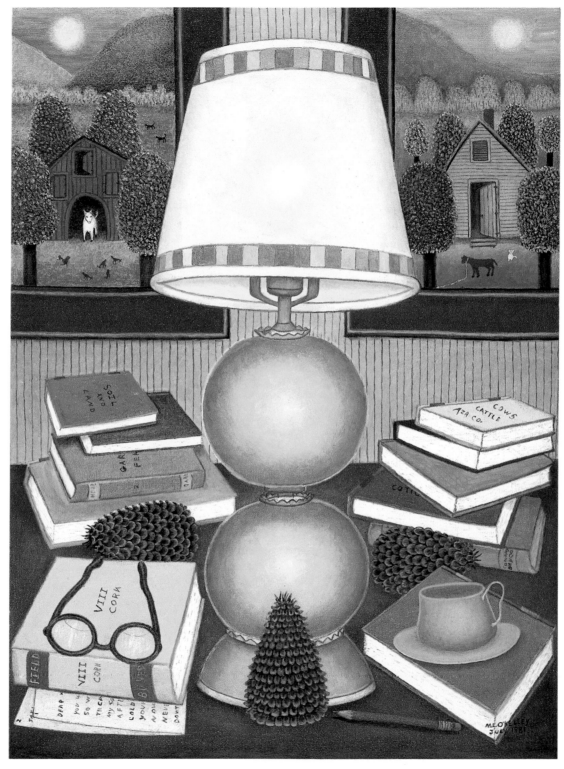

**READING TIME**

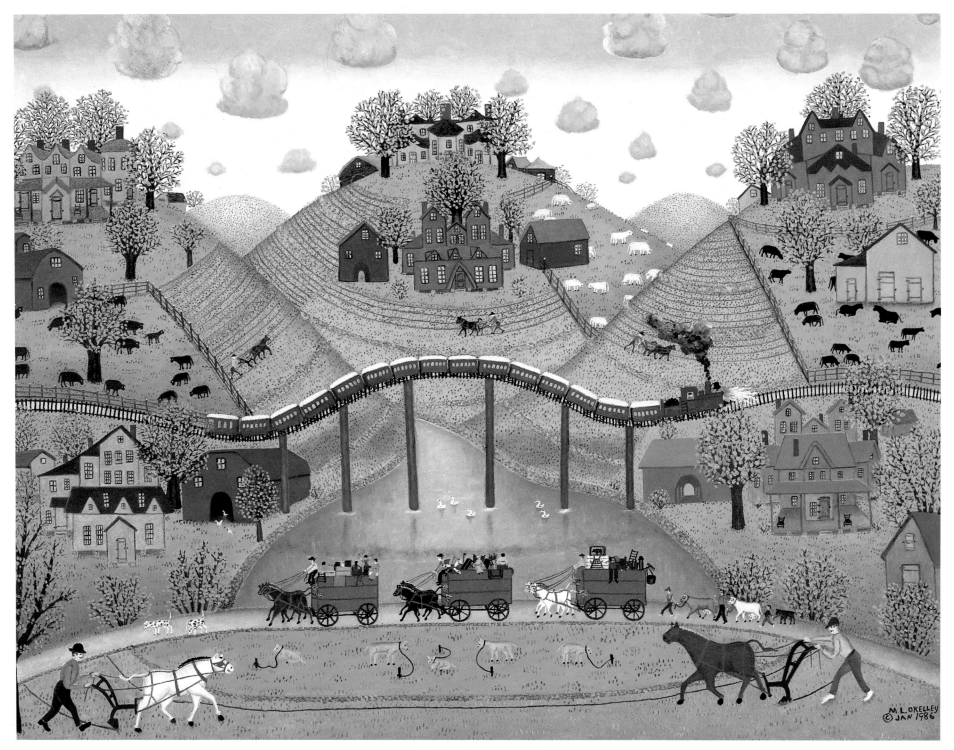

OVER THE BRIDGE

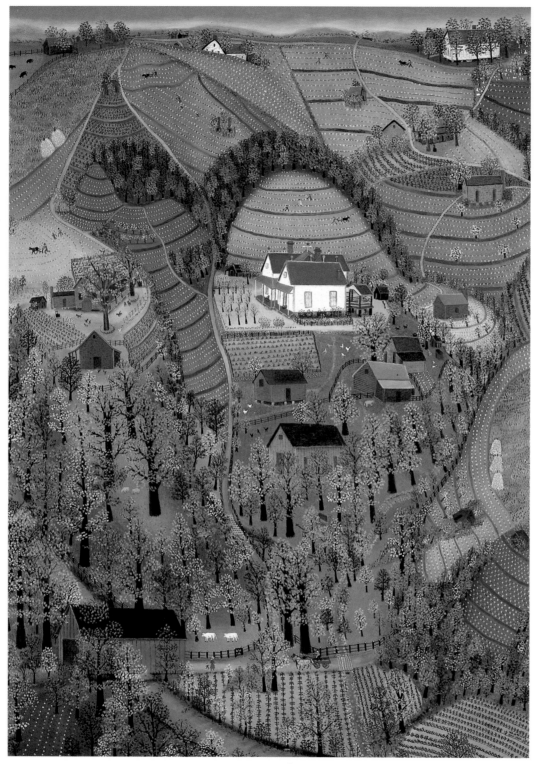

MY PARENTS' FARM

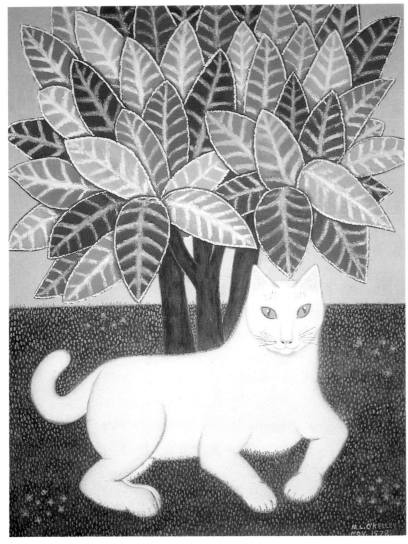

SASSY CAT

*This large white cat belonged to a next-door neighbor when I lived awhile in Florida. He spent a great bit of time in my yard at his ease.*

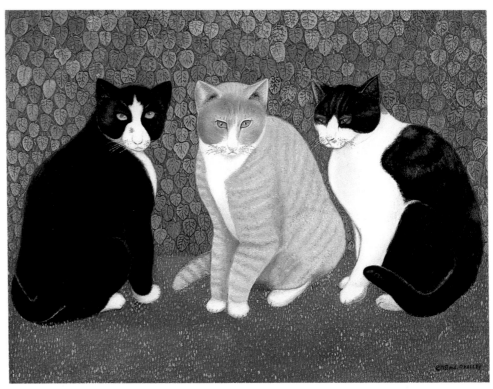

THREE CATS

17

*W*illie, Tom, and Ben shoe the mules, sharpen the field plows, and keep the farm tools in shape here in Papa's shop. It's my job to turn the grindstone and blow the bellows to make the fire red.

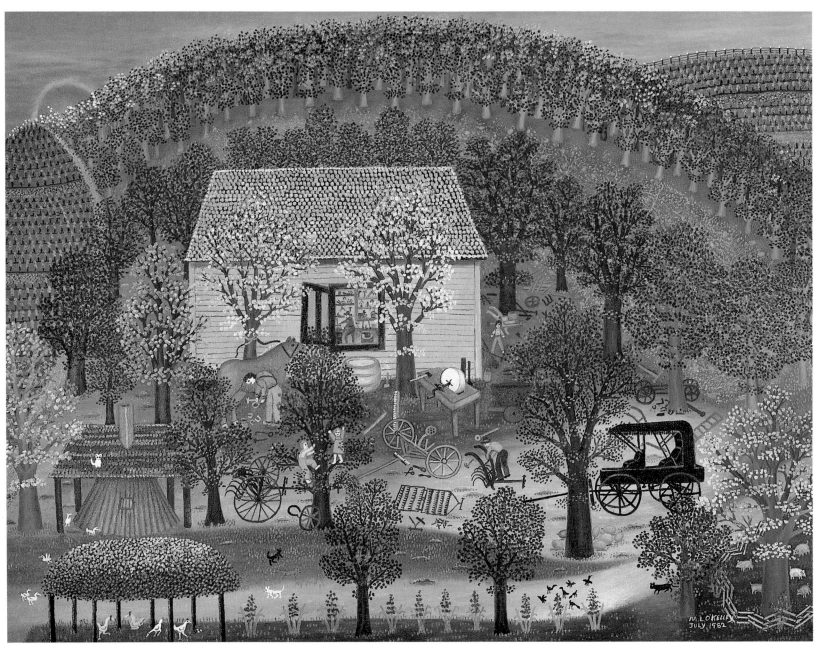

PAPA'S WORKSHOP

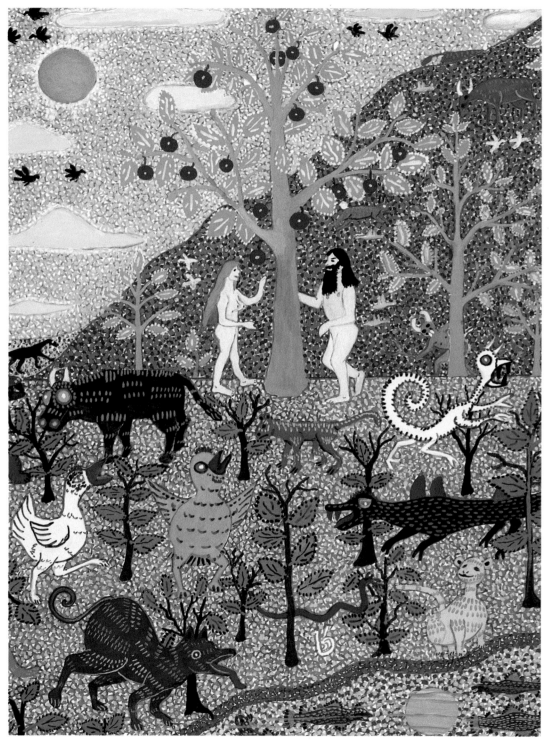

THE GARDEN OF EDEN

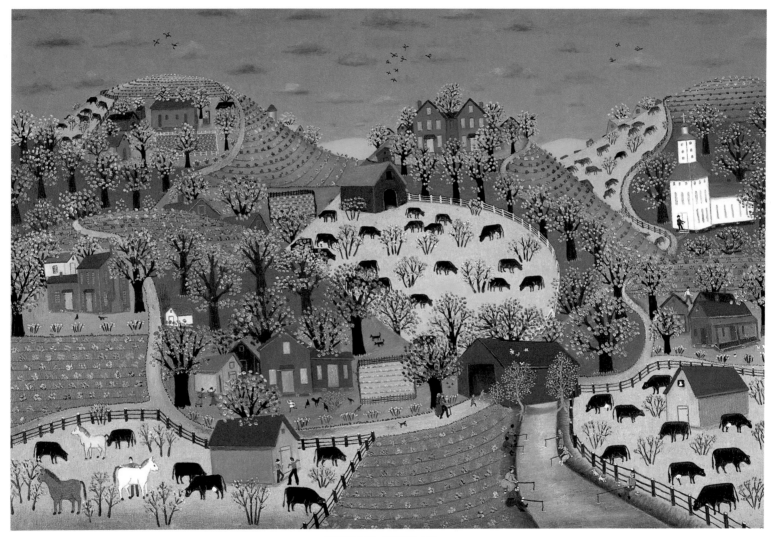

SUMMER SUNDAY

# SUMMER

Long, lazy days.

Juicy red watermelon waiting.

The luring aroma of golden cantaloupes

on the back porch. Canning in the kitchen —

soups, vegetables, preserves.

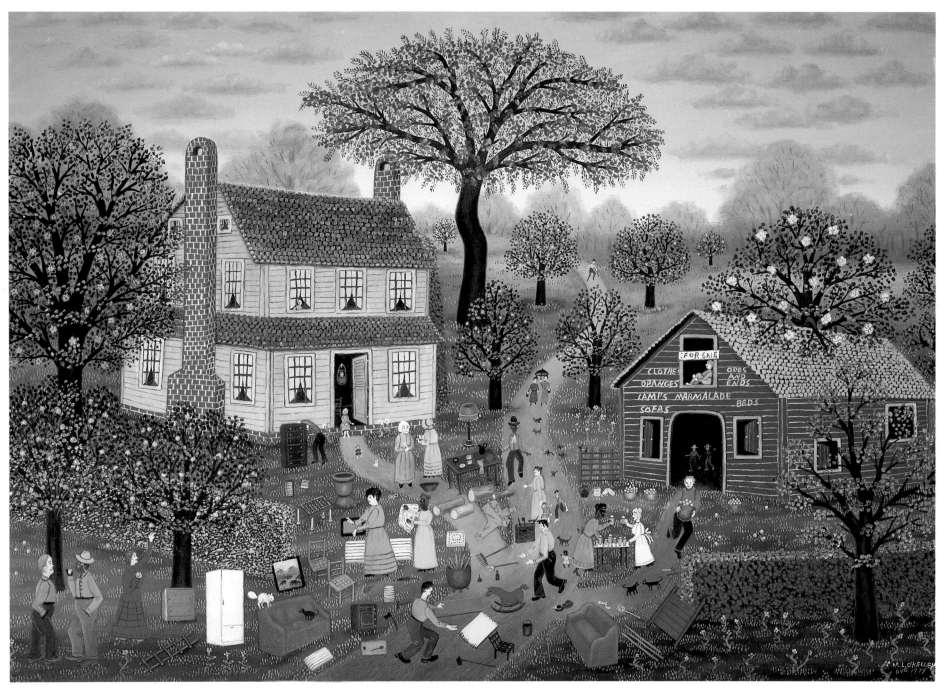

YARD SALE

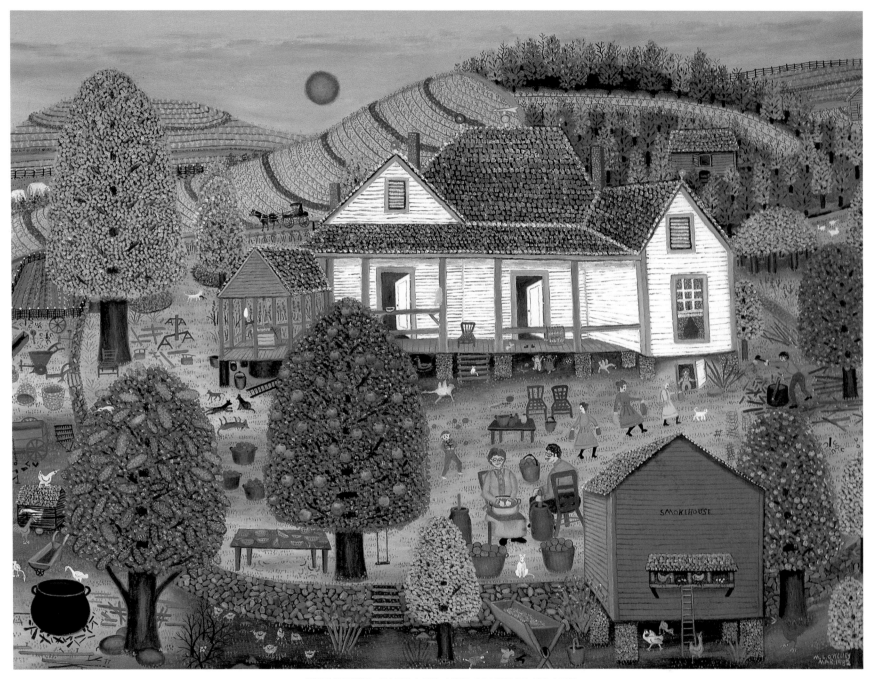

**CHOPPING CABBAGE AND MAKING KRAUT**

Mama and Papa are chopping up cabbage and beating it down into big crocks to make kraut for the coming winter.

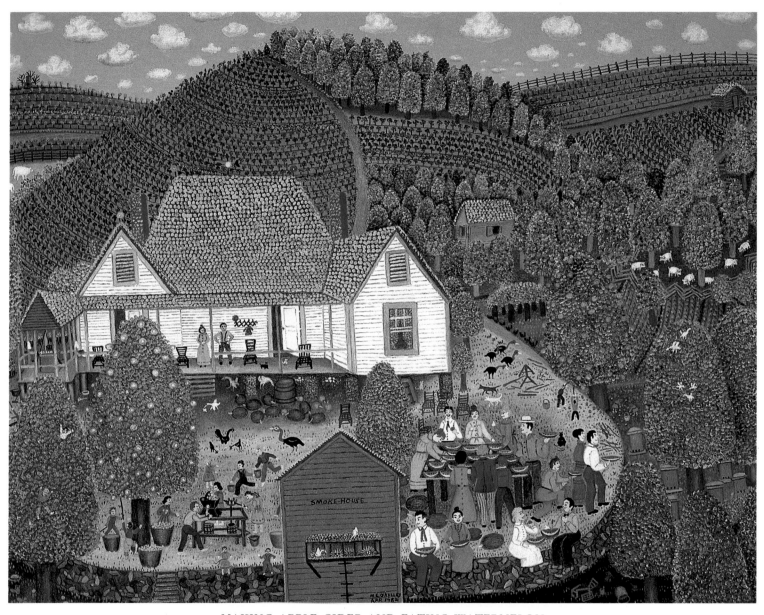

MAKING APPLE CIDER AND EATING WATERMELON

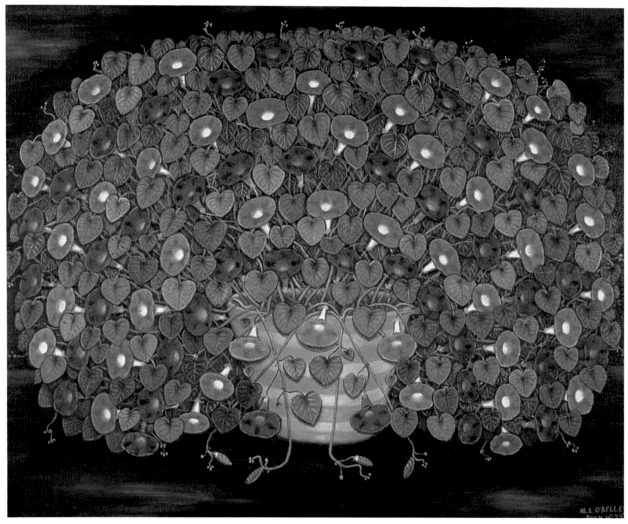

MORNING GLORIES

Sometimes I wish I had all the morning glories I ever painted, and could give a morning glory show in the dead of winter.

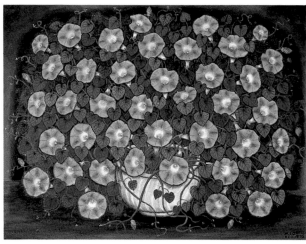

BOWL OF MORNING GLORIES

25

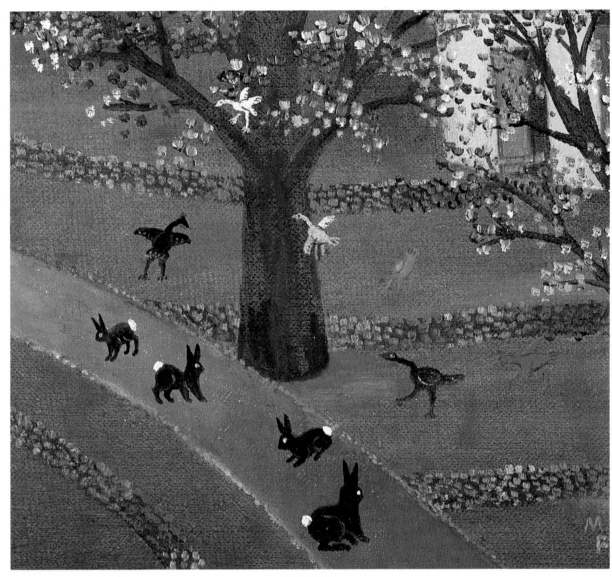

DETAIL

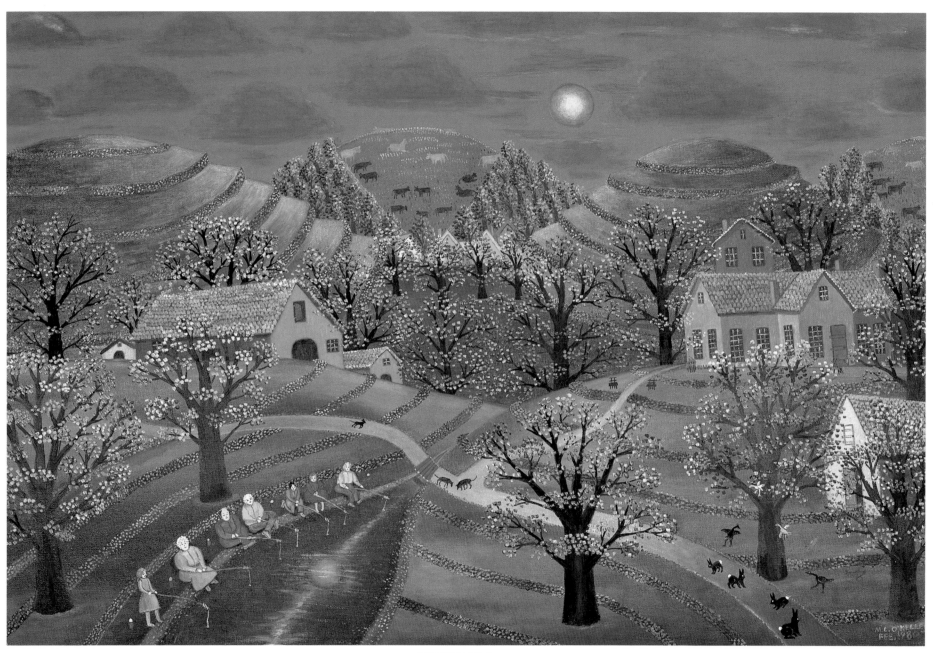

NIGHT FISHING

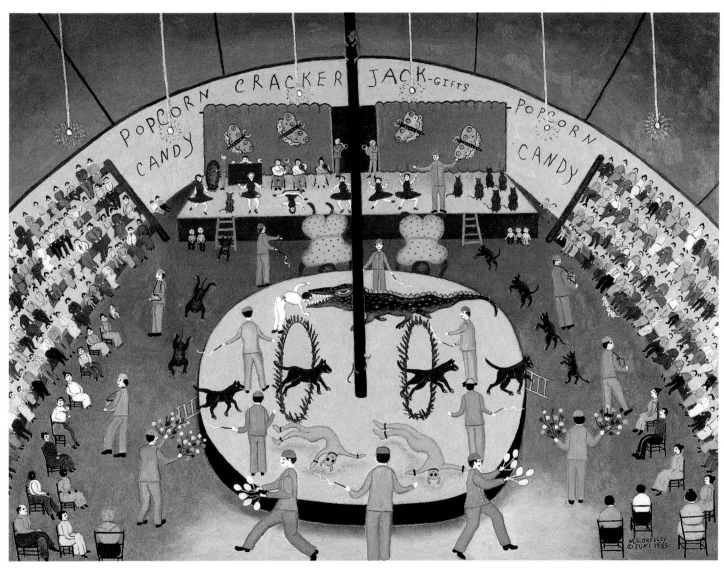

INSIDE THE TENT

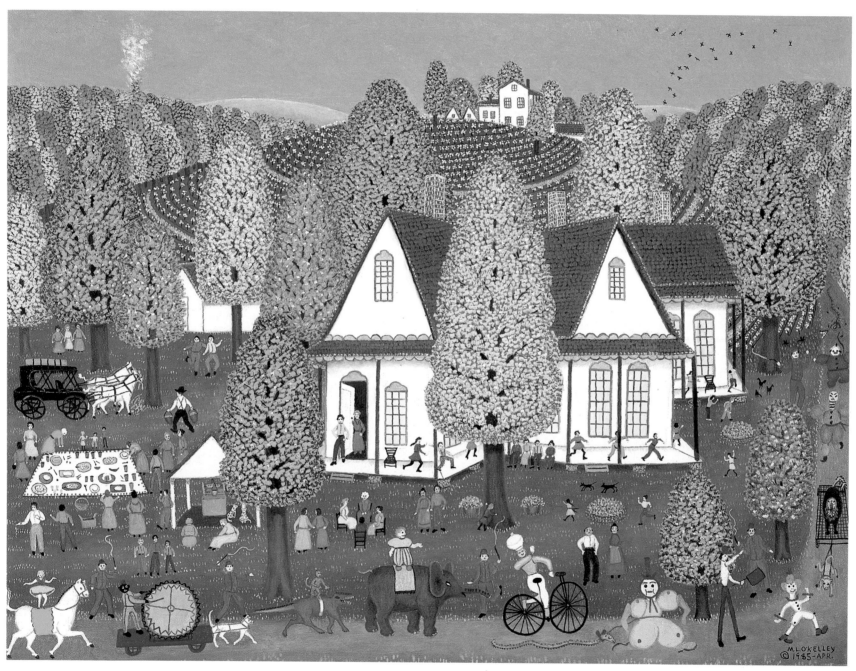

COUSIN EMMALINE'S

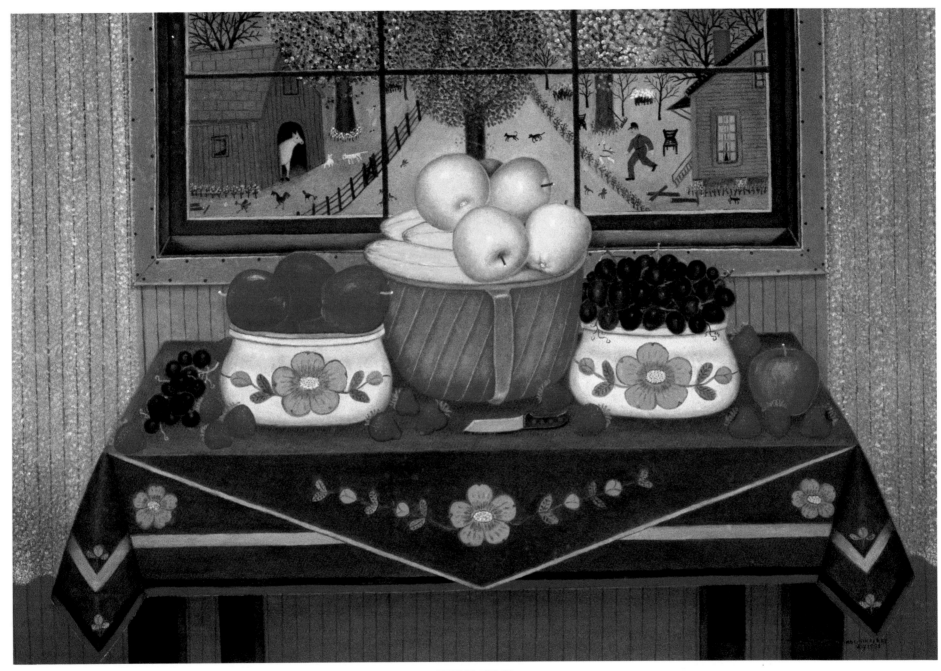

FRUIT TIME

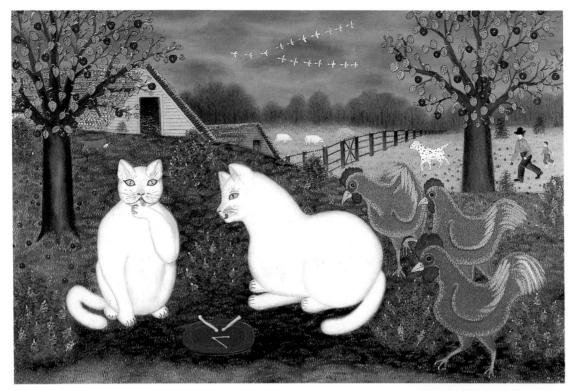

STRANGE MEAL

With the geese going south for the winter, the cats eat up the last of their chicken dinner, unaware of their shocked audience.

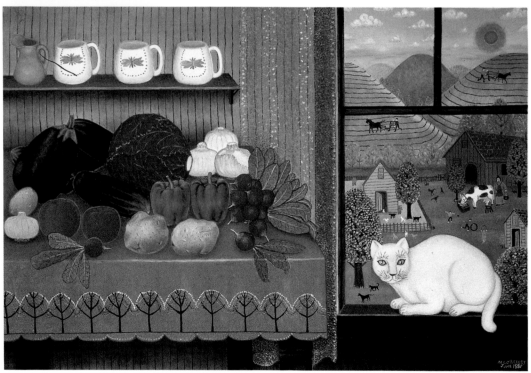

THE FARMER'S KITCHEN

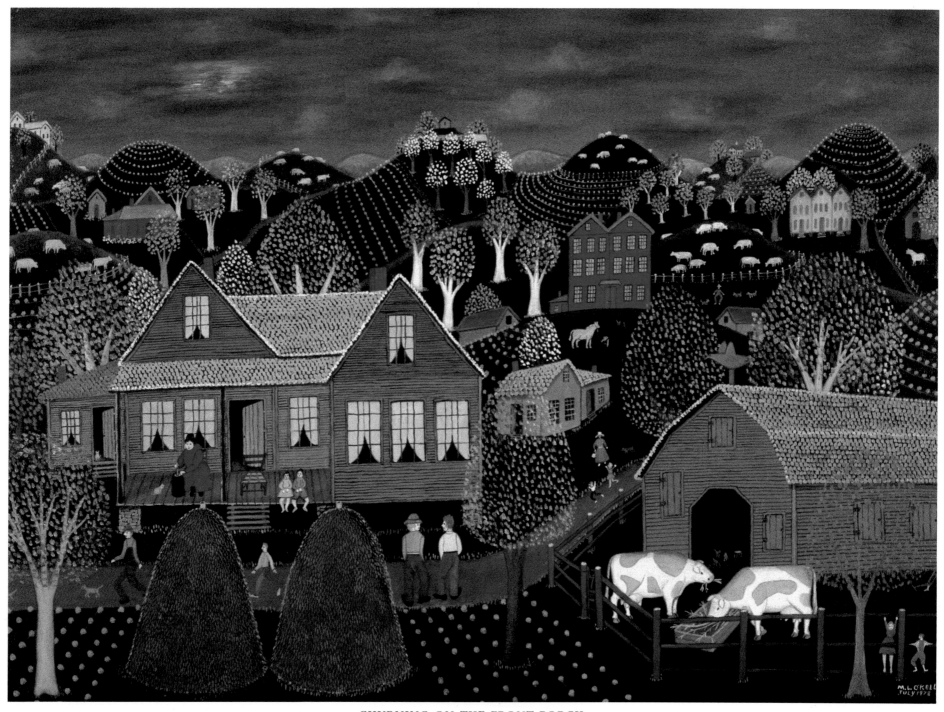

CHURNING ON THE FRONT PORCH

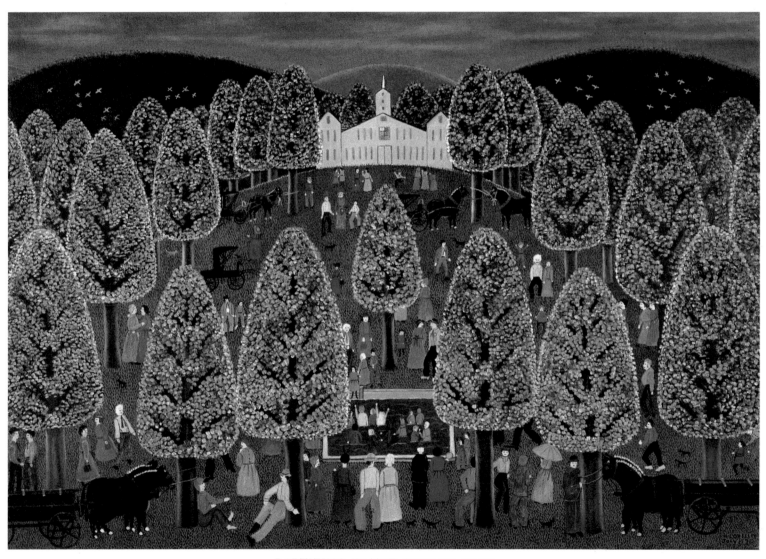

BAPTIZING IN THE CHURCH POOL

33

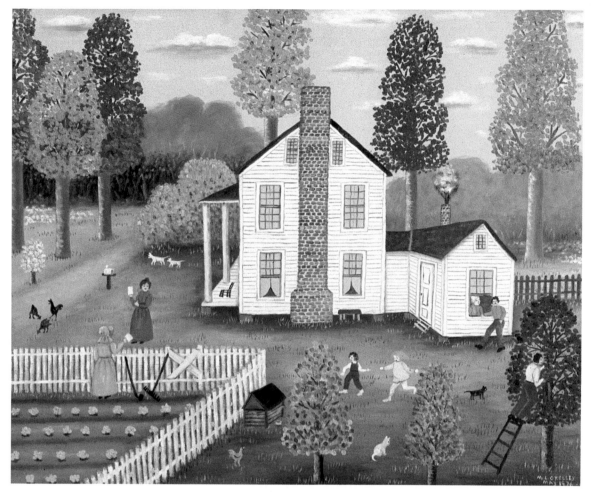

SHARING THE LETTER

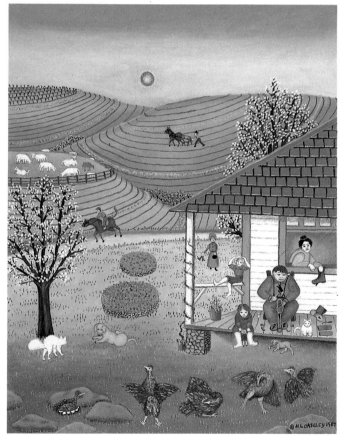

SHOEING THE SHOES

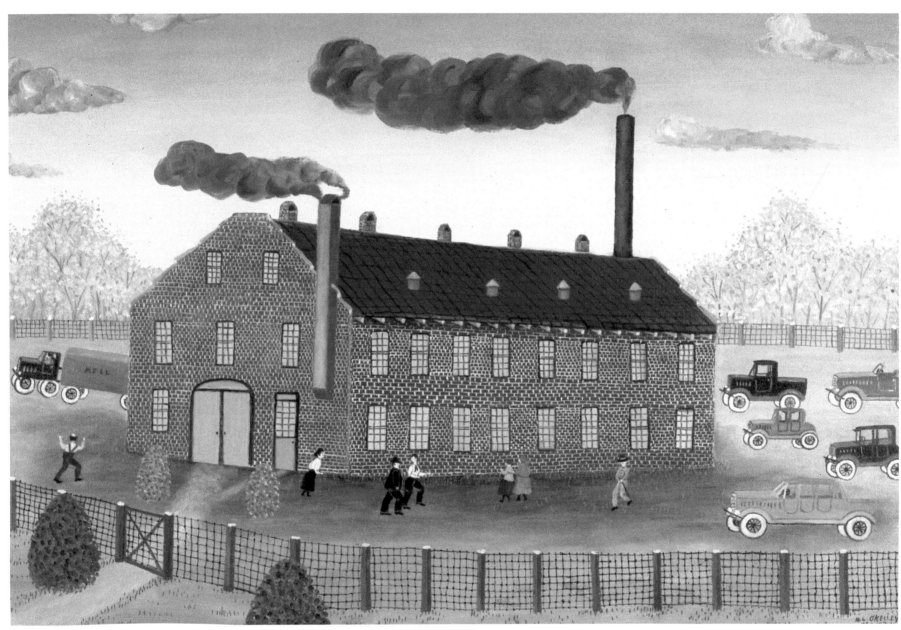

THE OLD MILL

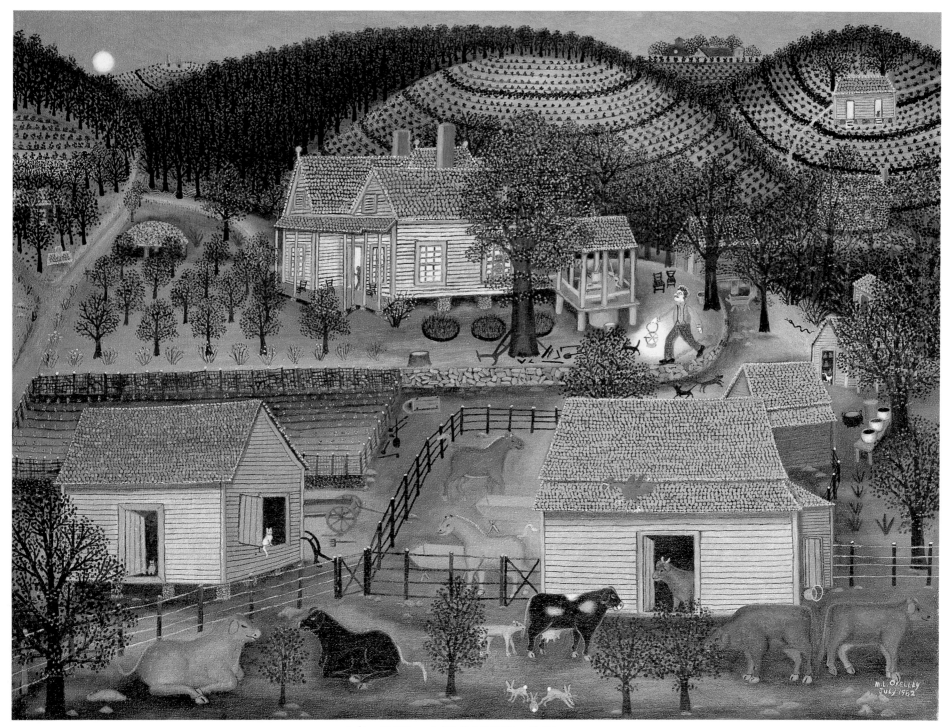

PAPA FEEDING THE MULES AT FOUR A.M.

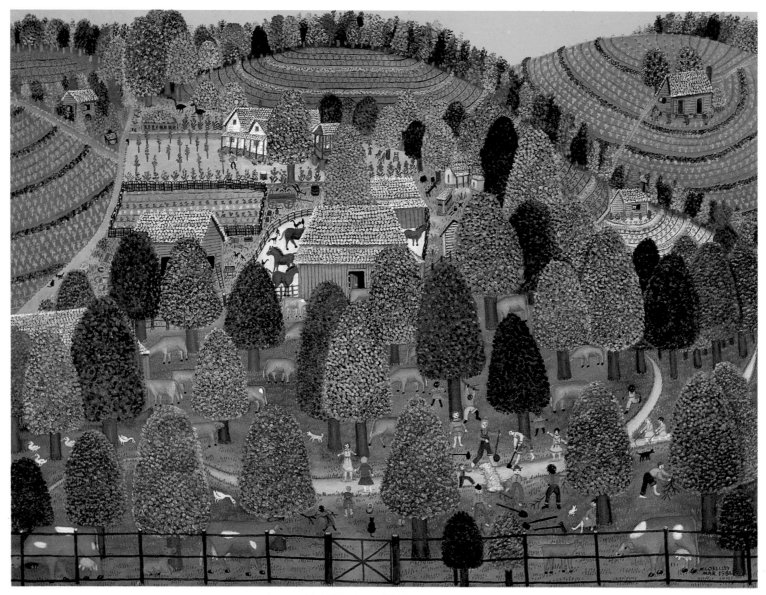

PLAYING IN THE BRANCH

The branch that runs in the pasture below the house is one of my favorite spots.
On hot summer days Johnnie and I build a dam so that we can go wading.
We look for crawfish, minnows, and little green snakes.

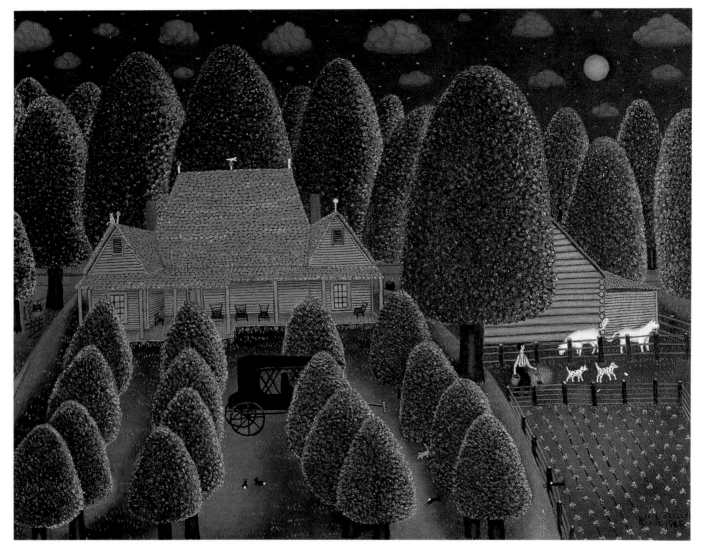

HOME

# AUTUMN

✦

Cotton waiting for the market.

Winter around the corner. The leaves are

turning, giving up their season.

When the grain threshers came, it was a big time at our house. The menfolks rushing around the barns, the whine of machinery, Mama wringing a chicken's neck, putting new green beans in the pot, sending me and Johnnie out to pick wild blackberries for a fat pie.

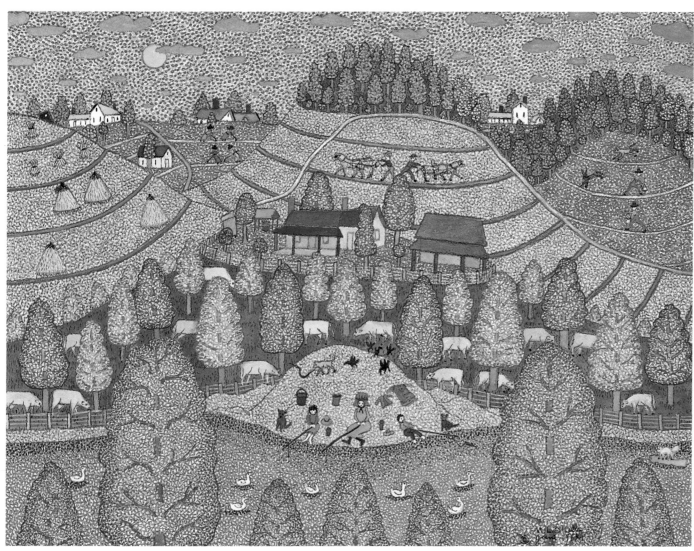

**AUTUMN**

40

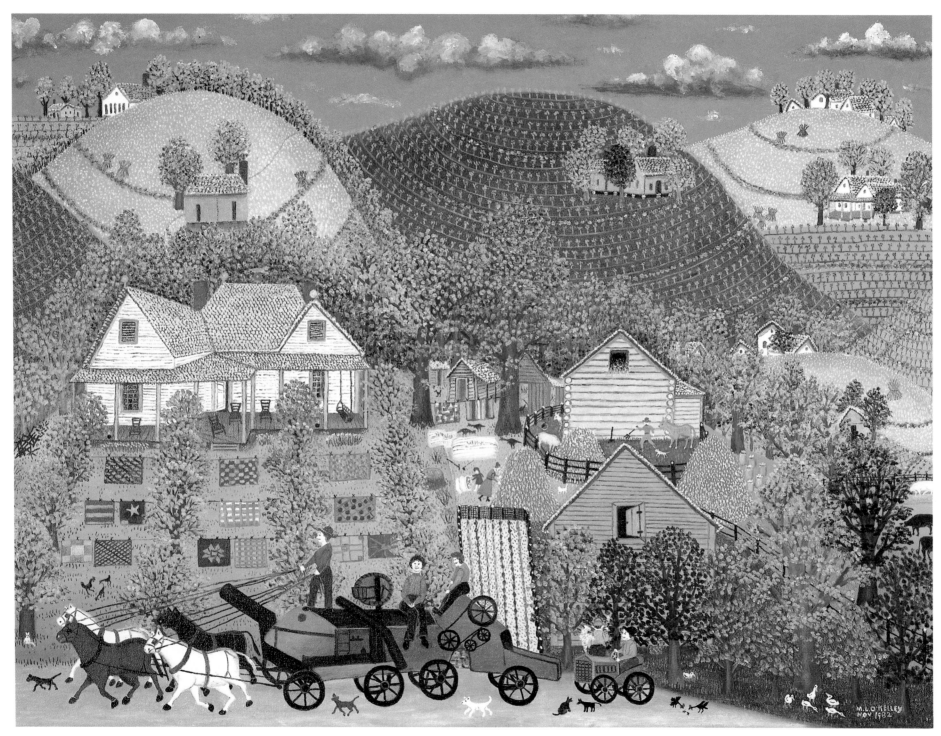

THE THRESHERS LEAVE

41

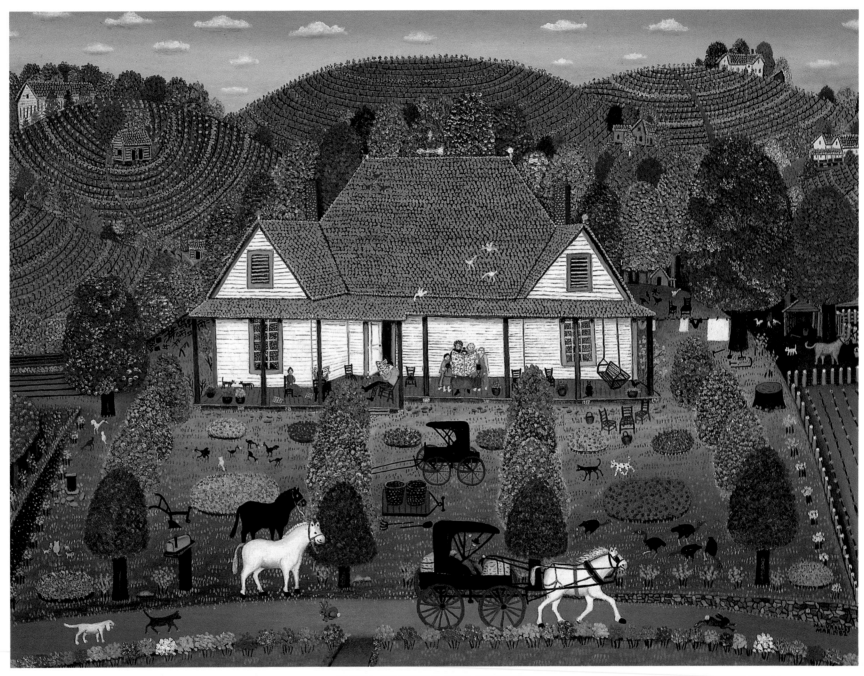

MAMA READING THE FUNNIES

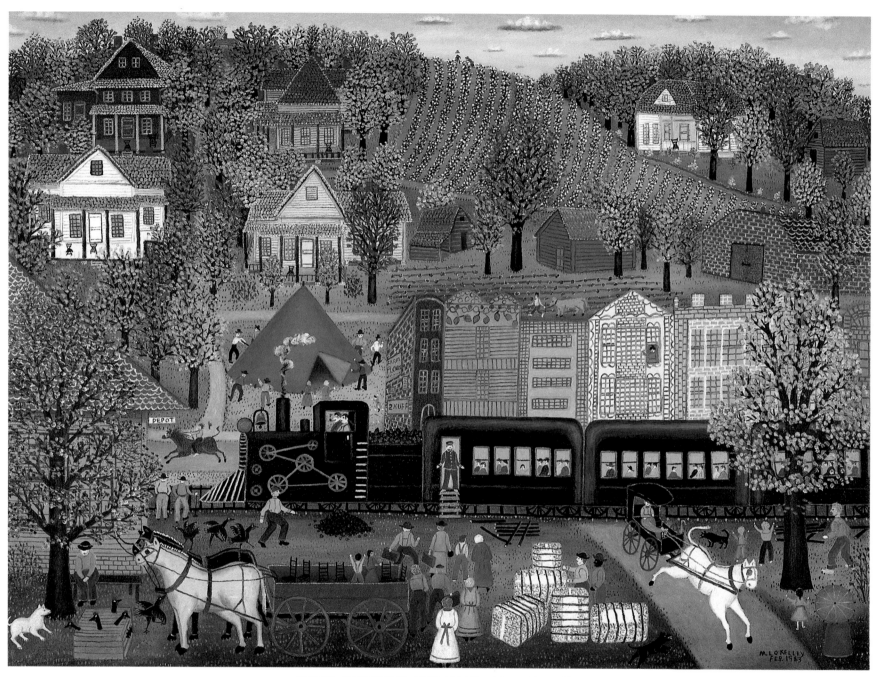

LILLIE CATCHING THE TRAIN FOR ATLANTA

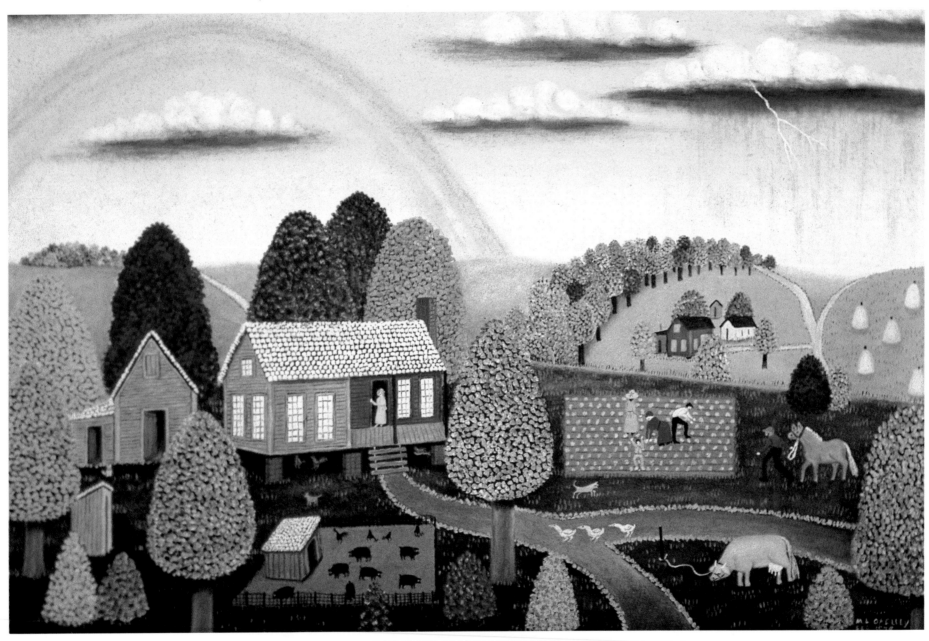

RAINBOW ON THE HORIZON

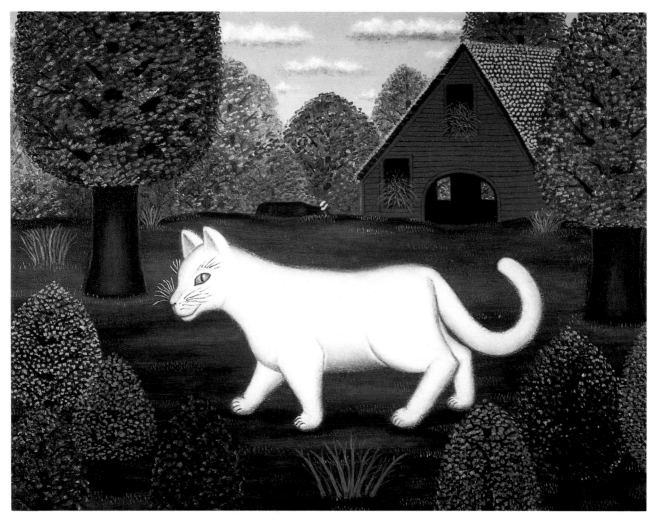

BARNYARD CAT

*O*n *a trip out of Florida I looked out the window and saw gorgeous clouds — they held me spellbound.*

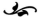

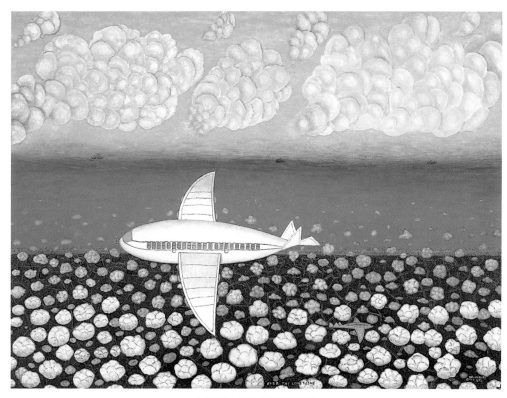

**AIRPLANE PICTURE**

**WOMAN PICKING COTTON**

*H*ow well I remember picking cotton on my father's cotton fields. Terraced hillsides, soft white cotton in small one-room places built for storage till we had gathered a bale. Then the bales dumped in the yard where we kids loved to play on them. The cottonseed was stored in the barn for cow feed, replanting, and a soft bed for mother cat to find her babies.

46

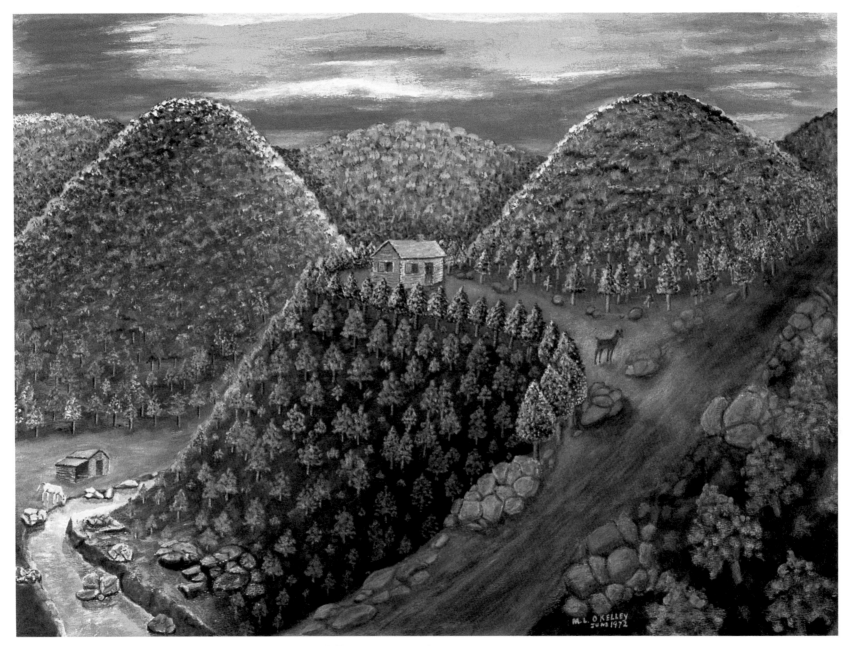

NEW ROAD IN THE MOUNTAINS

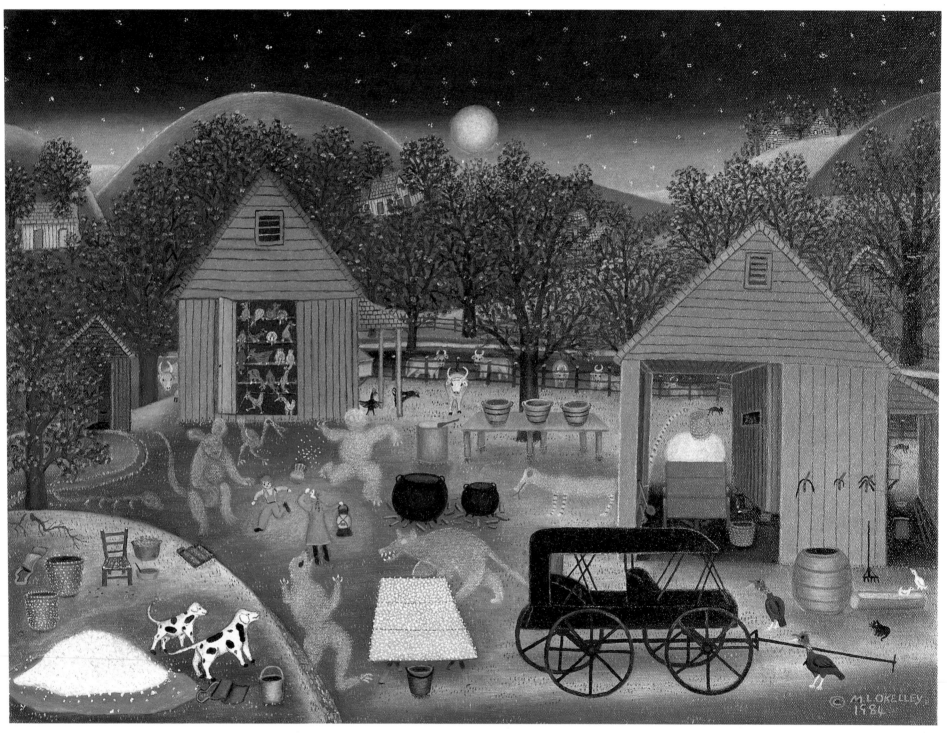

**GOOD MOON**

*T his one is wishful thinking. We would wish*
*we could go fishing when we had to pick cotton.*

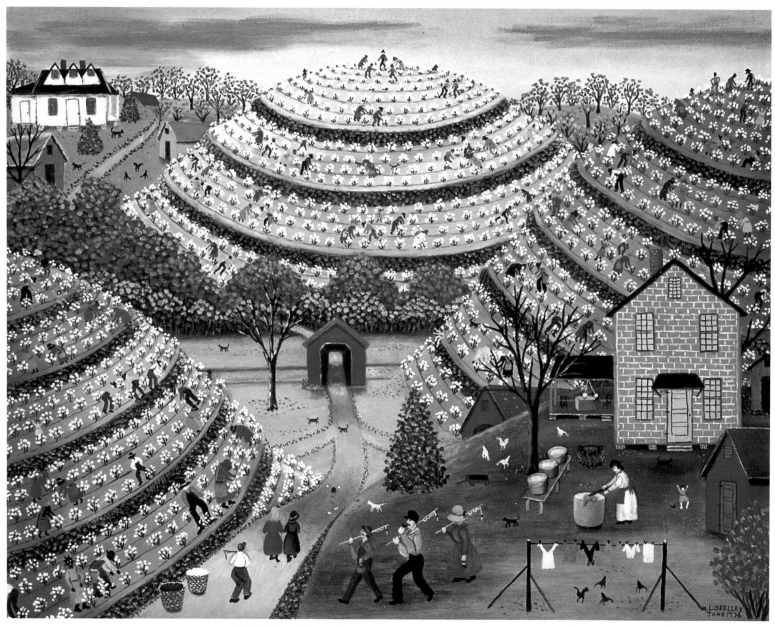

OFF TO FISH IN THE COTTON PICKING SEASON

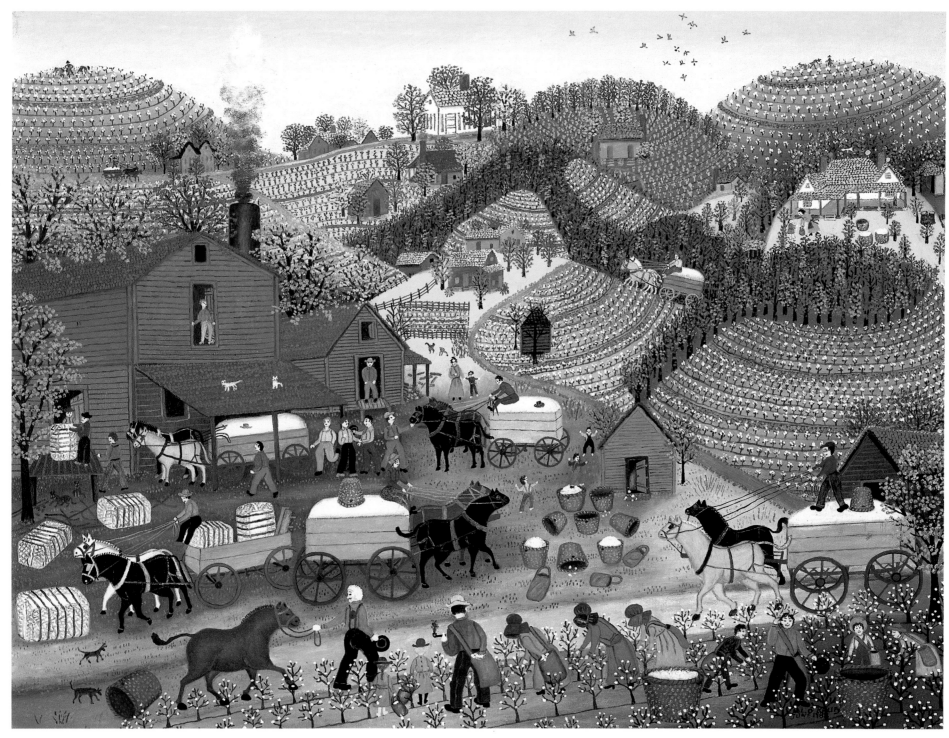

COTTON GINNING TIME

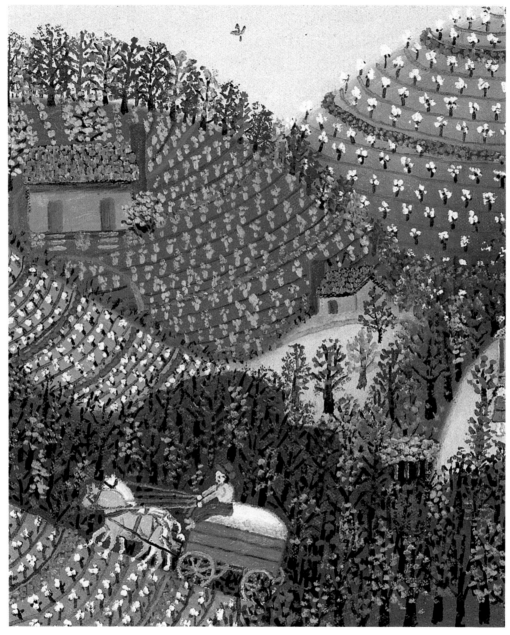

DETAIL

Though this is not the family cemetery, it is a sort of composite and reminds me that when Gertrude was buried, Mama would take me and Johnnie every week to Gertrude's grave. Just a touch here and there, a fresh sprig of flowers, a bit of grass to be pulled. Then it was Johnnie who Mama and me went to see beside Gertrude. Then it was Papa beside Johnnie and Gertrude. Then it was me to go see Papa, Johnnie, Gertrude, and Mama.

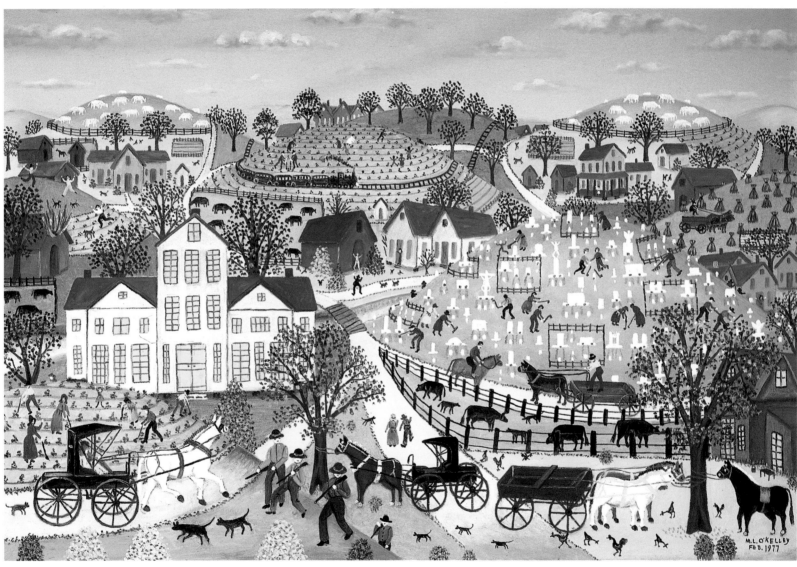

CLEANING OFF THE GRAVEYARD

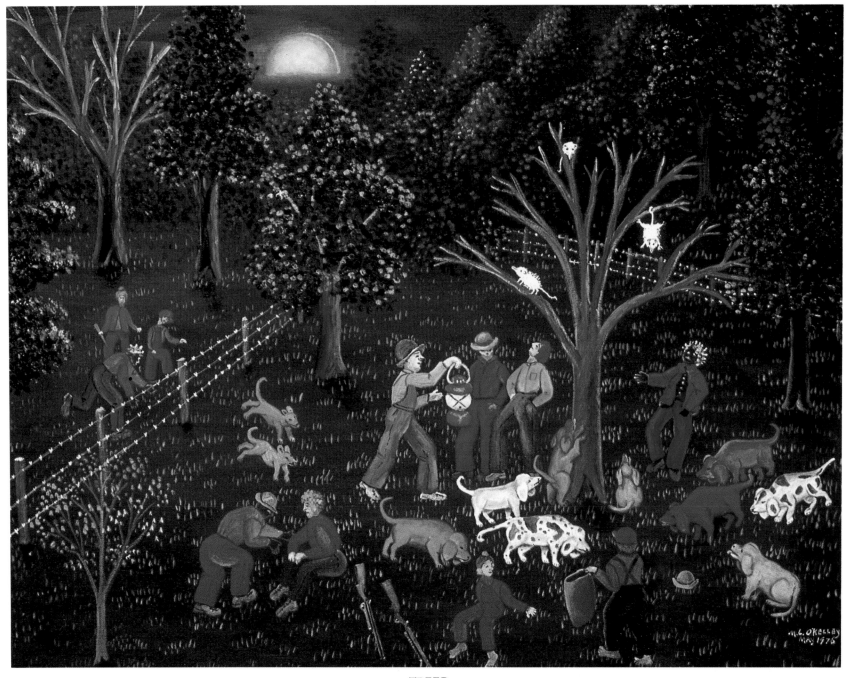

TREED

 possum hunt was a lot of fun. My brothers hunted possums quite often.

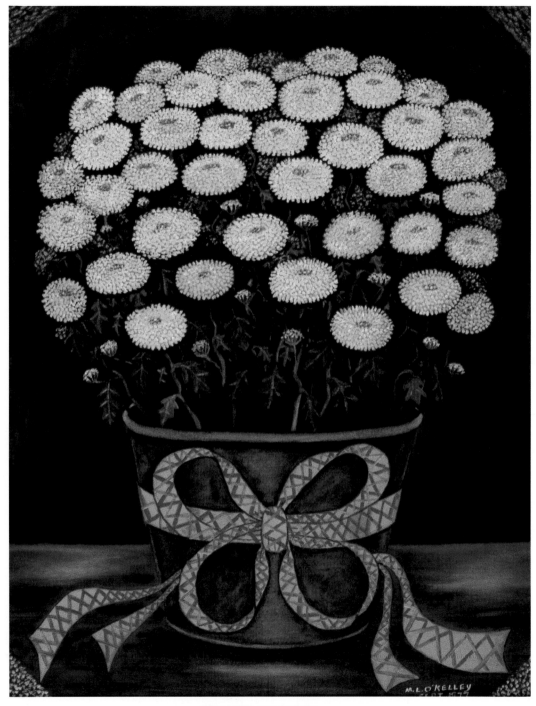

BUCKET OF MUMS

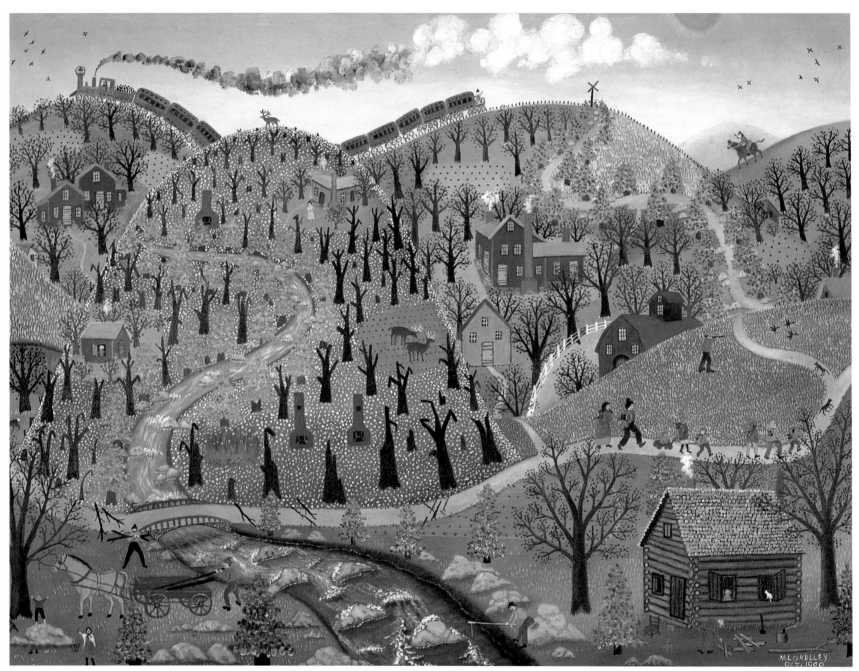

THE FIRE-SWEPT MOUNTAIN

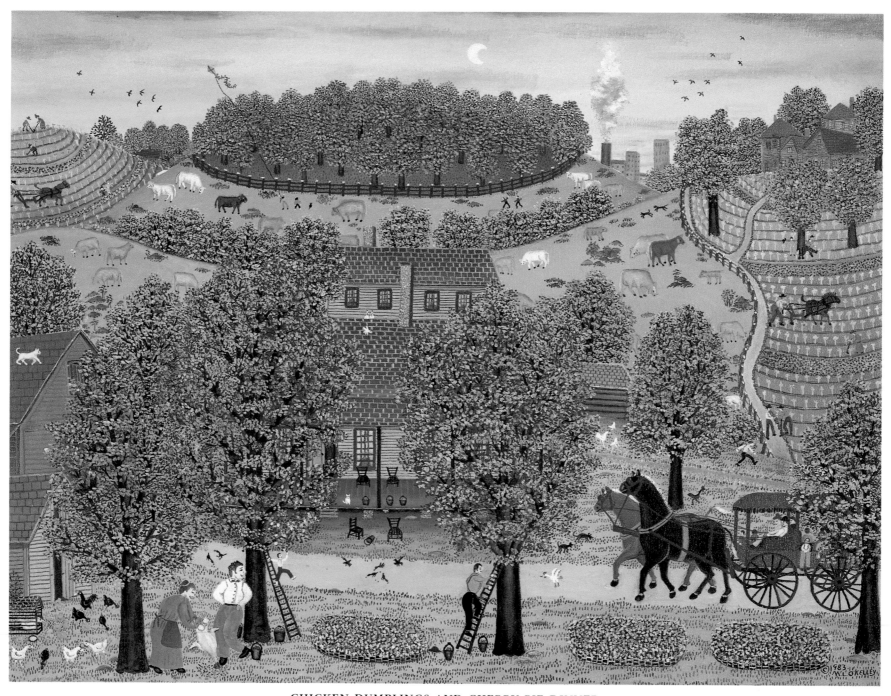

CHICKEN DUMPLINGS AND CHERRY PIE DINNER

    **T***ime for everyone to come home.*

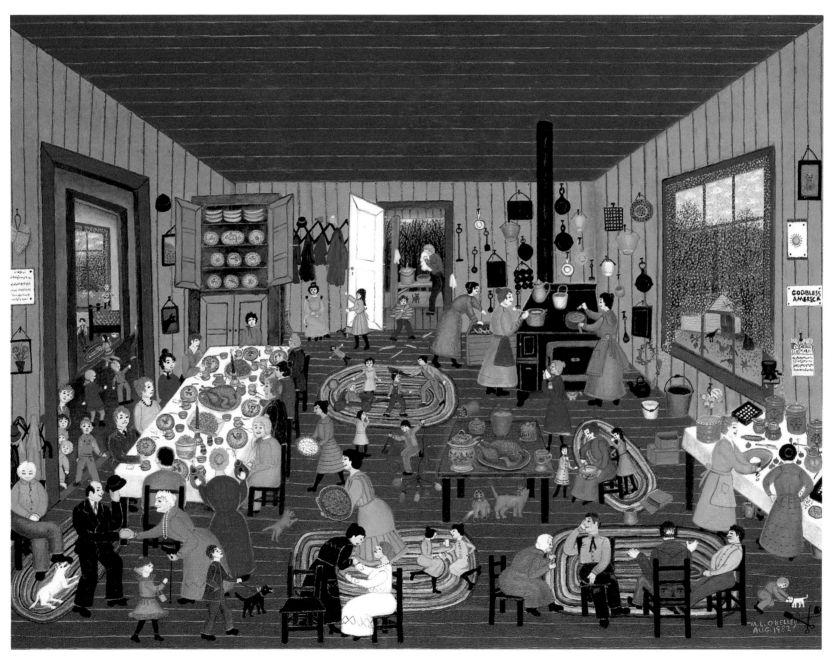

**THANKSGIVING**

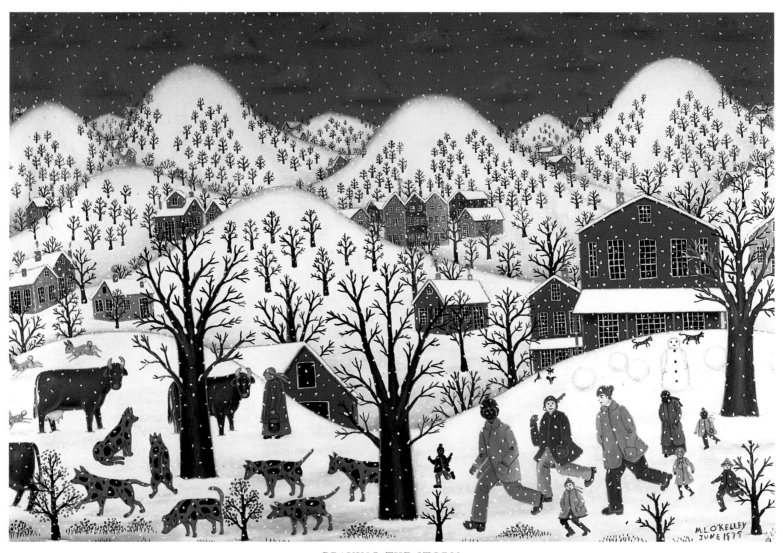

BRAVING THE STORM

# WINTER

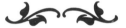

Rare snow in Georgia brings
on a celebration. Ice cream! Fresh snow,
sugar, vanilla, and warm milk from the cold
farm cows in the white pasture.

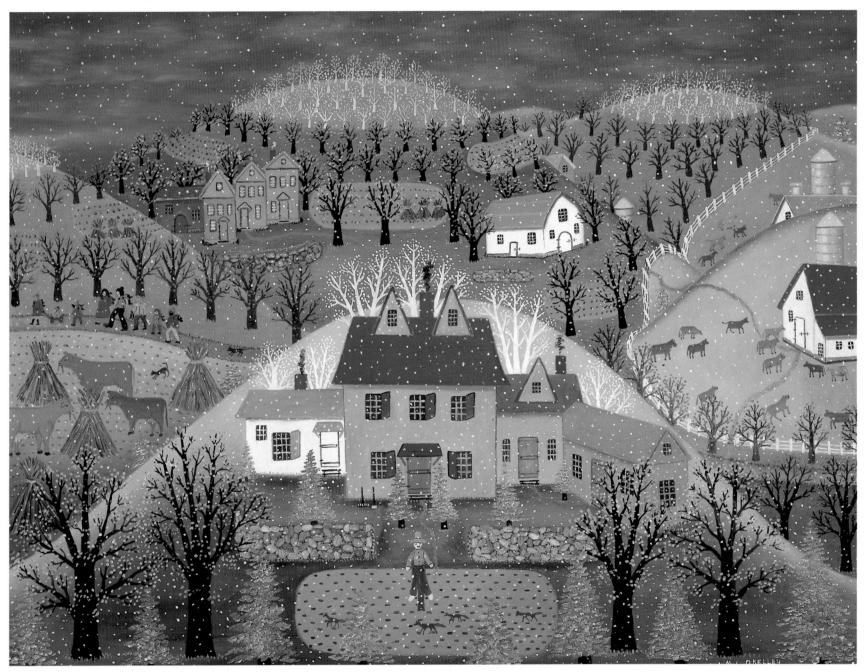

THE FARMER'S LAND

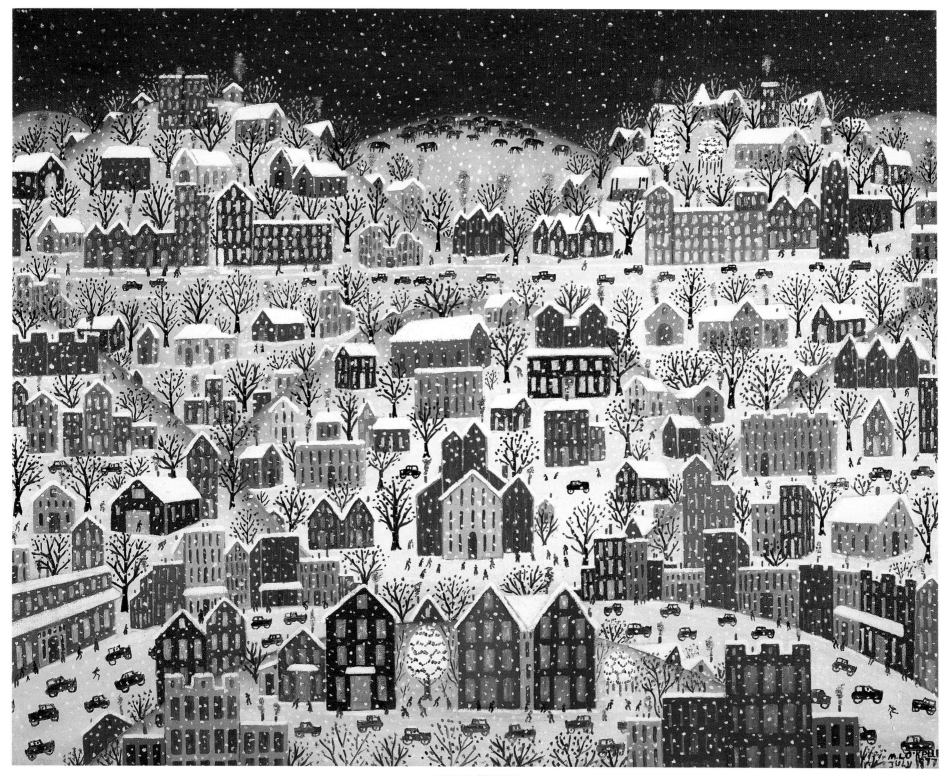

HILLY TOWN

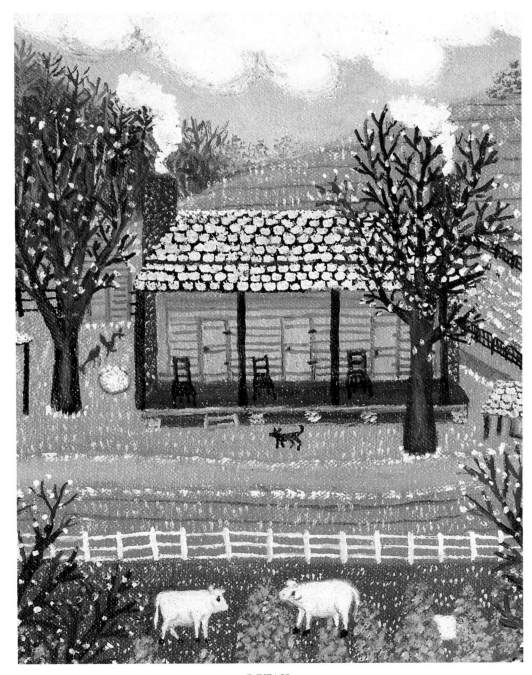

DETAIL

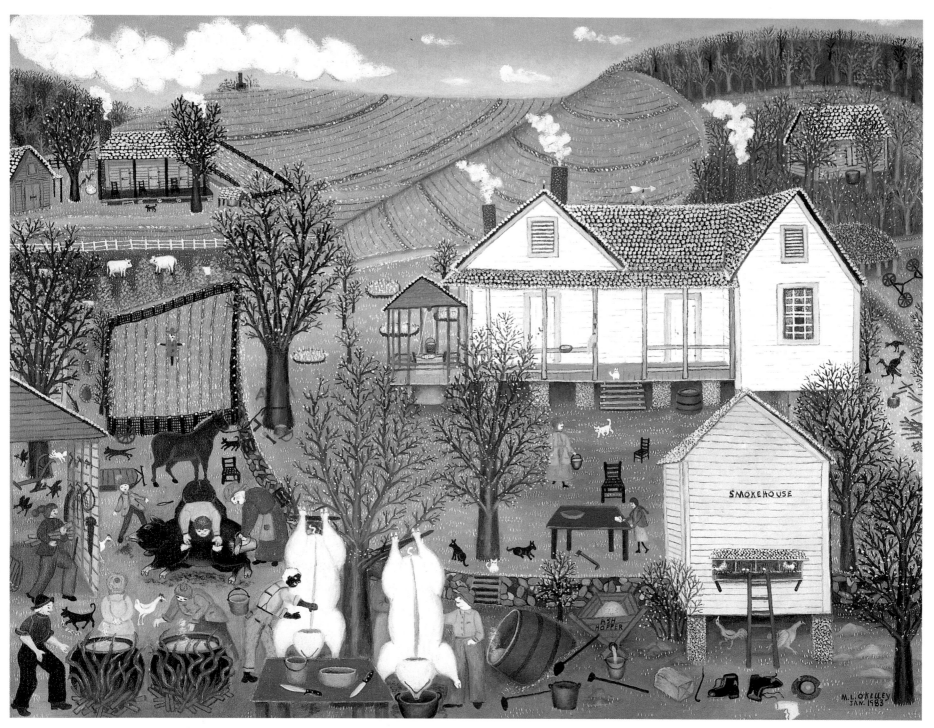

KILLING THE HOGS

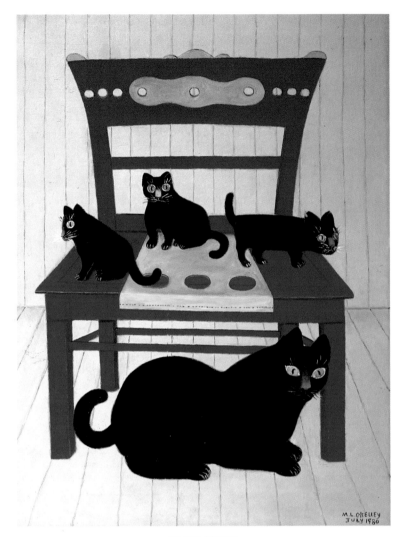

PLAY TIME

We had cats on the farm and the cats had kittens. My mother would come in from milking the cows and say, "There are some kittens in the barn," and out we would run screaming in delight.

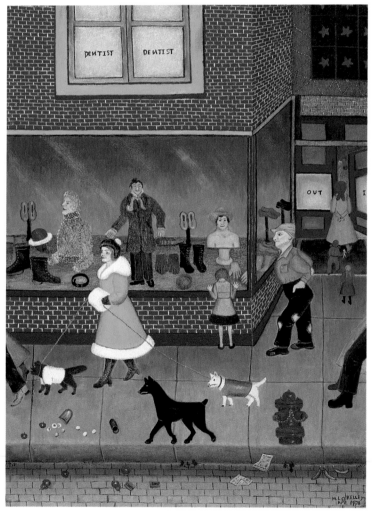

WINDOW SHOPPING

64

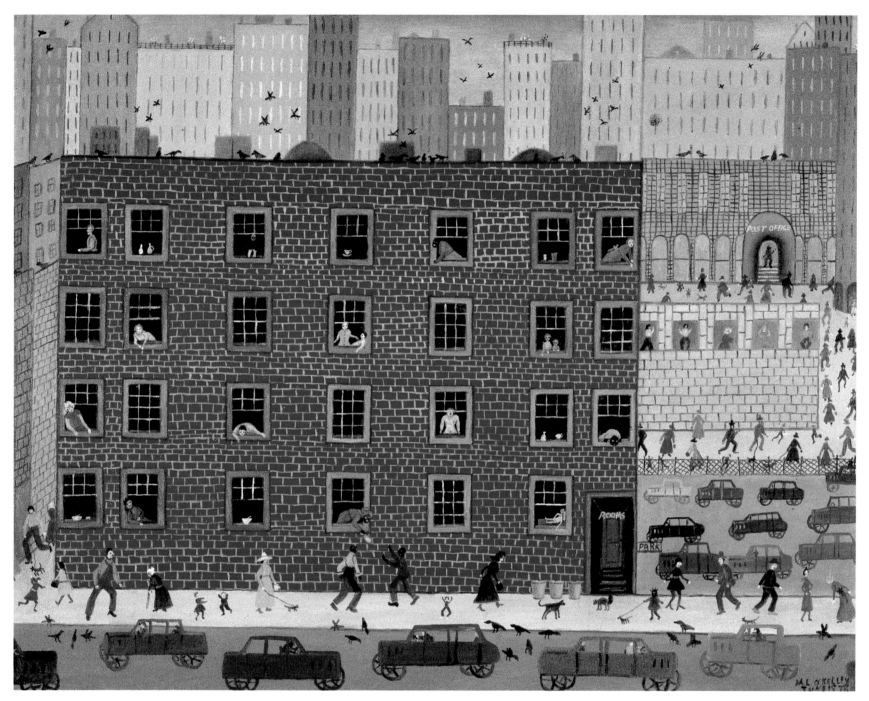

ROOMS

The view across from my studio apartment in New York City. I could see a lot of things across the street, where there were rooms to rent.

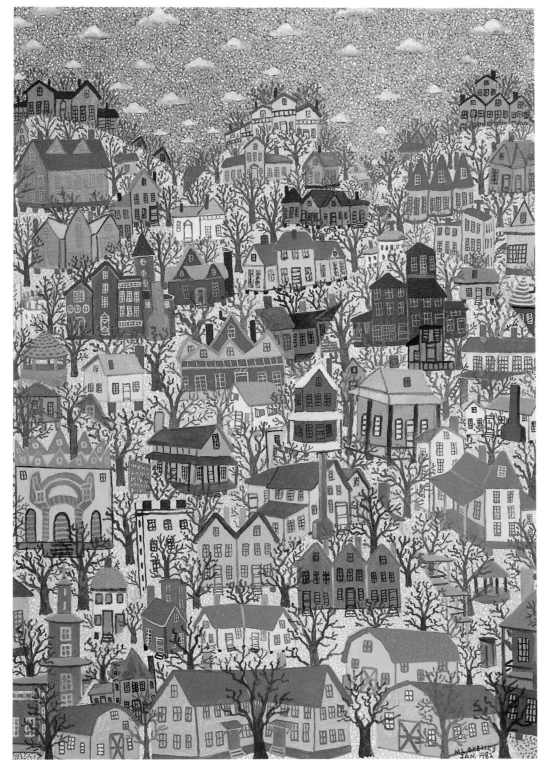

WINTER VILLAGE

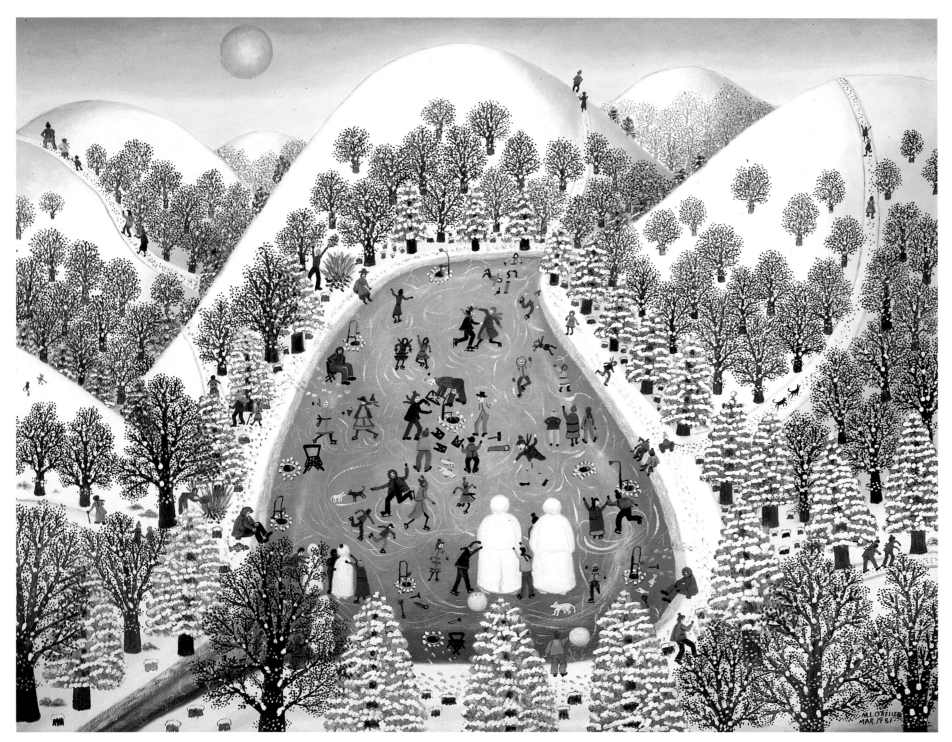

THE LONG WAY HOME

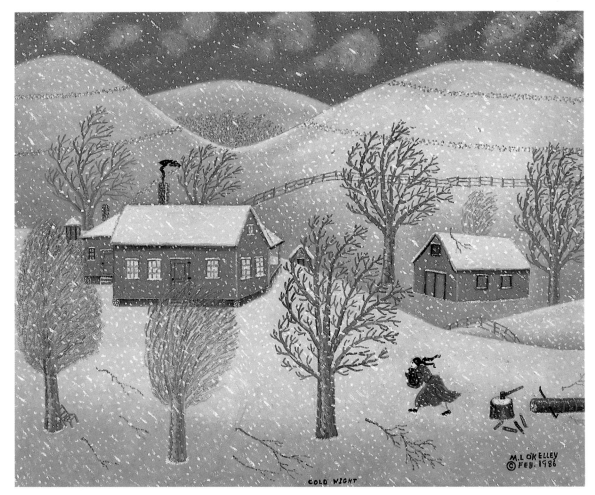

COLD NIGHT

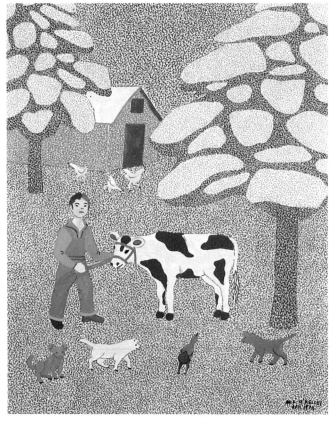

BOY AND CALF

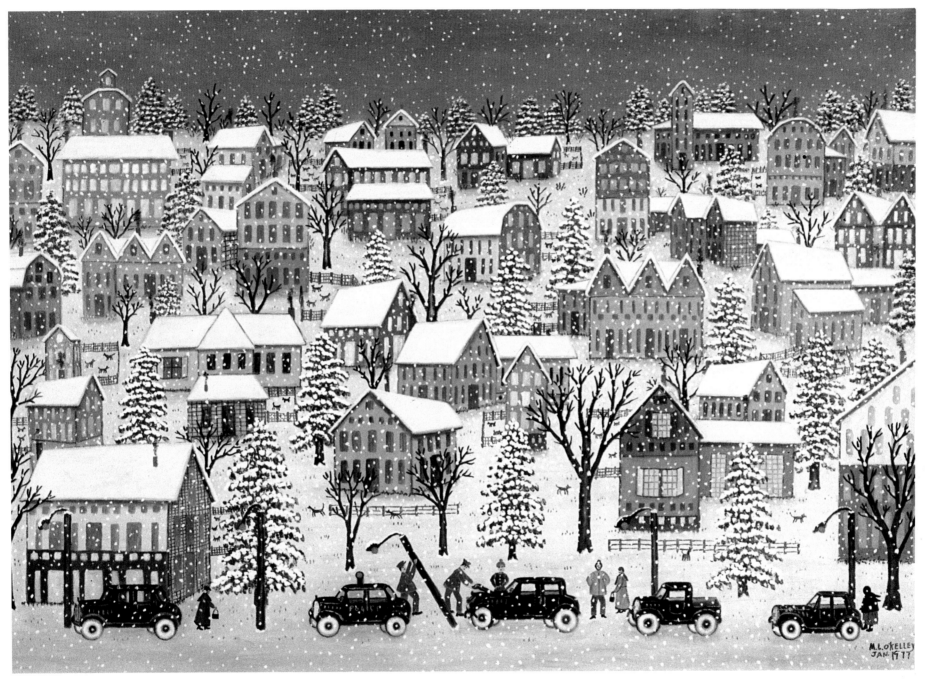

SNOW WRECK

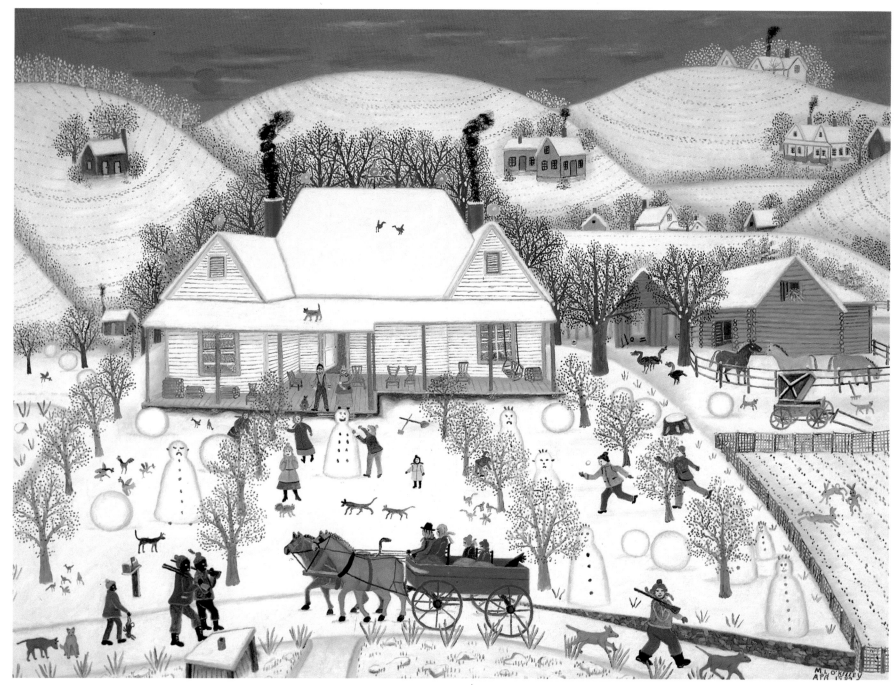

LATE SNOW IN GEORGIA

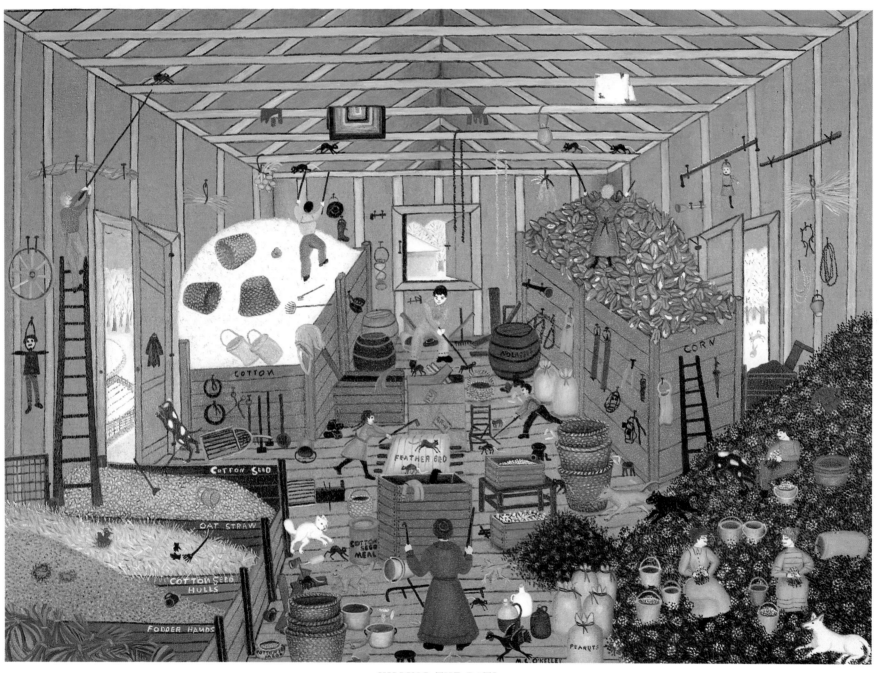

**KILLING THE RATS**

O̶ur cats could never catch all the mice and rats in Papa's barn. And the rats were smart enough to avoid being caught in Papa's traps, so once winter would come, and the crops were gathered and stored, we took after those rats with a vengeance. Otherwise they would make a real dent in Papa's corn, wheat, and peanuts.

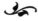

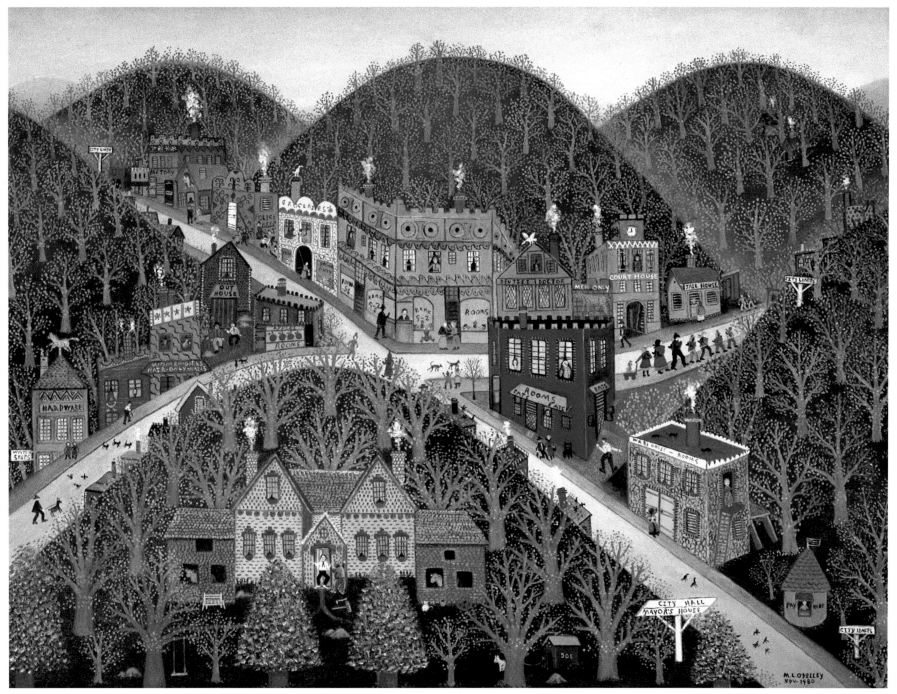

MOUNTAIN TOWN

*The sun cuts across the mountaintops, catching the faraway snowcaps and bringing out the bright colors of the houses in the valley.*

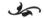

**CHILLY AFTERNOON**

# MATTIE LOU O'KELLEY

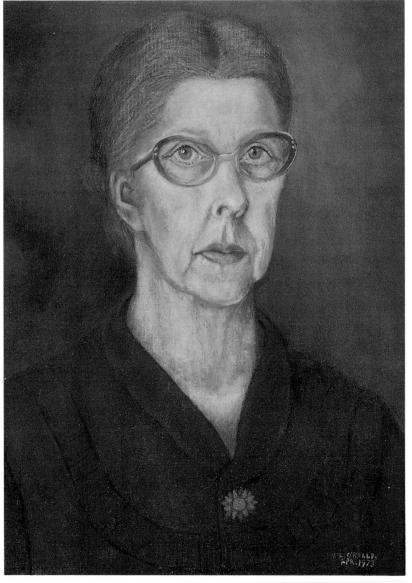

**SELF PORTRAIT**

# Autobiography

I was born on my parents' farm
In 1908.
I was then the seventh child,
Three years later, eight.

My father always worked hard,
And did survive
To till the hills, to plant his crops,
That we survive.

Our mother was an honest Texas girl
Who loved the terraced land,
These things she bred into her children,
A peachtree switch in hand.

My childhood was a happy one,
I loped the hills,
I chased the calves, ran the rats,
I had no frills.

My youth was an unstable lot,
Lost was I,
My body shot straight up, and I
Became terribly shy.

In Banks County, Georgia, this was no sin,
All I knew
The whole world had turned around,
My outside sights were few.

I made no friends, I had no beaus,
I stayed at home.
I piddled at this and that,
I did not roam.

I read and read, each moment lovely,
A twilight's purple down.
Invisible stars filled my silent head,
They would not let me down.

But unknowingly we breathe time's grip,
We ride a legless horse,
We go each to our very own,
Happiness or remorse.

A public job I acquired and never liked,
Ten public jobs I got,
Ten jobs I never did like,
The boss never forgot.

Now my one room house has only me,
I never roam,
No lessons have I, but I paint
And paint
And stay at home.

— M. L. O'Kelley

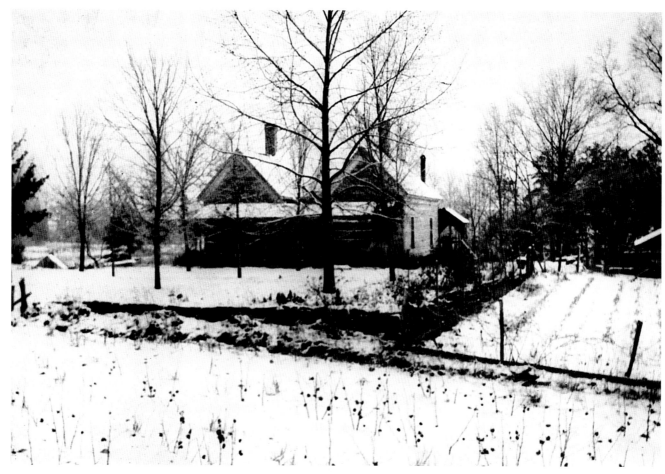

THE O'KELLEY HOMESTEAD, MAYSVILLE, GEORGIA

*T*his is the home place. I was born here — though the front porch was not there then, nor the well shelter (far right). Mama would bring an apron full of rocks from the fields every day when she worked to build the rock wall on the right side of the yard after Papa had built the house and graded off the yard. Papa had lightning rods on the house to keep away the lightning.

# The O'Kelley Family

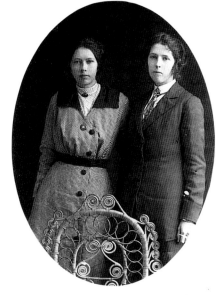

GERTRUDE AND LILLIE

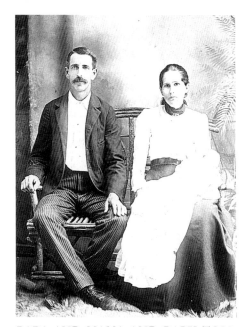

PAPA AND MAMA AND BABY TOM

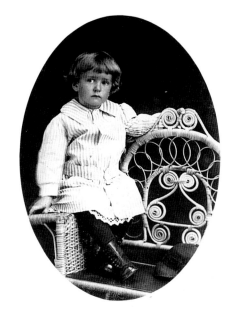

JOHNNIE

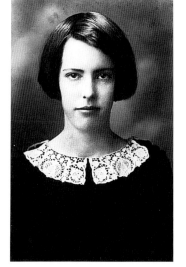

MATTIE LOU

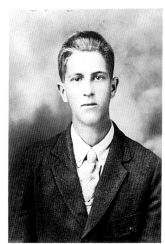

BEN

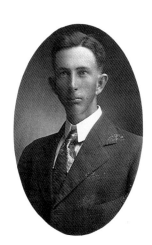

WILLIE

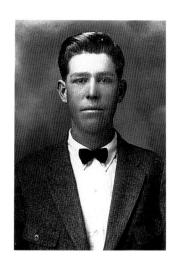

TOM

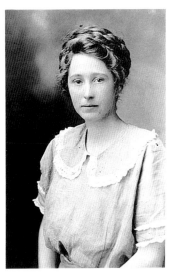

RUTH

attie Lou O'Kelley paints all day every day unless something keeps her from it; it's rare that something does. She doesn't want — and has no need — to see people other than a few family members, a few friends, and an occasional business or publishing associate. O'Kelley is shy and private, and because nothing brings her more pleasure than painting and reading, she sees no reason to, when possible, do anything but paint and read. She can't imagine what else could make her any happier than she already is in her daily life.

O'Kelley can imagine plenty when she wants to, however. Growing up with seven brothers and sisters and a set of hardworking parents on a 129-acre hill farm in rural Maysville, Georgia, O'Kelley, when not working, would mostly entertain herself by reading and letting her imagination bloom. As the tallest girl around (five feet ten inches eventually, and embarrassed and bashful because of it)

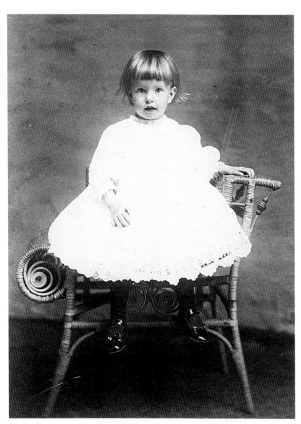

EMILY MATTIE LOU O'KELLEY, CA. 1910

and a loner and dreamer by nature in lieu of close friends save her younger brother Johnnie, O'Kelley relied on her fantastic imagination to keep herself happily occupied.

When she shut her eyes as a child, O'Kelley remembers visualizing dots of colors in clumps and shapes. She didn't see clouds in the sky; she saw animals and flowers. Her oldest sister, Lillie, liked to duplicate pictures from magazines and bought pastels for herself and her younger sister. But Mattie Lou soon told Lillie she didn't want to copy existing pictures, she wanted to dream up her own. O'Kelley believes her temperament, her imagination and creativity, her ability as a painter, were born in her: "I had something special in me from

M*e, given the long name of Emily Mattie Lou. Emily for Mama's sister Emily, Mattie after Mama's mother, Lou after a neighbor woman and friend of Mama's.*

the start." Her artistry is an outgrowth of all these things. "I have good thoughts — that's why I have good paintings."

O'Kelley labored on the family farm for close to half of her life. Picking cotton and making quilts, watering livestock and canning vegetables — country life was hard, but it taught her about good work habits and determination, two things she has in abundance. Her papa and mama never once complained about the nonstop chores of their profession, or the challenge of raising eight children, or the dedication necessary to become owners of their own land after starting out as tenant farmers. O'Kelley appreciates her disciplined yet fun-filled upbringing, and it shows in her paintings. Her love of family and homestead, painted from a clear memory of her childhood, are intimately revealed in painting after heartfelt painting.

Following the death of her mother twenty years after her father's death, O'Kelley, at age forty-seven, in the absence of a family nest for the first time, was faced with living alone. She had worked discontentedly at numerous mundane jobs — the only ones open to someone with a ninth-grade education — for years to support herself and her mother; once alone, she moved into a one-room cabin next to a factory where she had been employed. It was there that with no training, O'Kelley started to paint as a pastime and hobby. "I have a vivid imagination — I can just sit all day and dream about things — so I began to put it down in painting and writing." When she was almost sixty years of age she turned her full attention to her painting. The American folk art world soon took notice.

It's not just reality that O'Kelley puts down on canvas. She often embellishes what she remembers with creations from her imagination, and with daring and beautiful colors. O'Kelley *lives* this same mixture of real, fresh childhood memories and fantasies that she creates in her head — she is preoccupied with her youth and with what she imagines each day. She lets modern life into her world, but only sparingly ("I have no interest in having a public life"). Yet from a very early age, she had a desire for fame: "I didn't want to be a nobody. I wanted to make a name for myself." She deals with the consequences of these two opposing goals by limiting her interactions and public appearances but gaining exposure of her work through books, sales, and exhibits as best she can.

It is fortunate for all of us that O'Kelley has carefully sheltered herself and protected her time, as long working hours and solitude are essential to her creative process. We are the beneficiaries of lively, tender, and wondrous art.

# List of Paintings

Edited by Janet Swan Bush

Editorial coordination by Hannah Taylor

Designed by Jeanne Abboud

Production coordinated by Christina Holz Eckerson

Printed and bound by Dai Nippon Printing Company, Ltd.

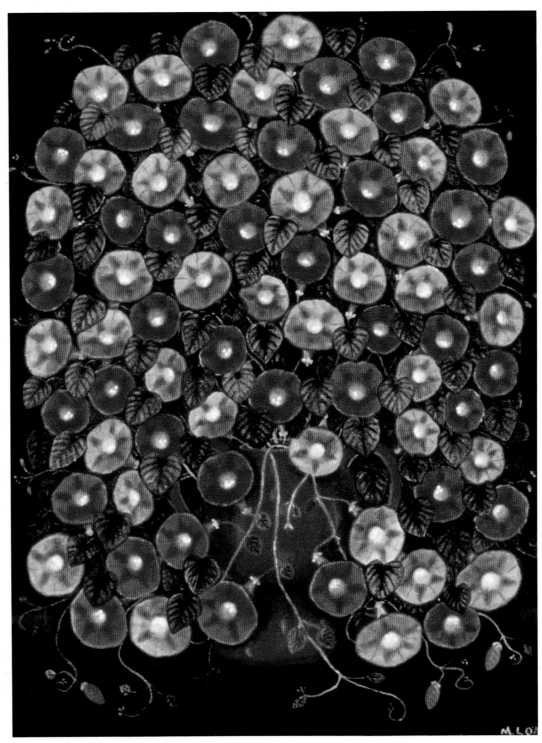

COLOR MORNING GLORIES